Indian art

This book is a comprehensive survey of the tendencies in the history of Indian art. It aims primarily to explain what different artistic forms meant to their makers, and to give some idea of the realities of Indian life which affected Indian aesthetics.

After referring to the earliest civilization of India, that of the Indus Valley, and interpreting some of its enigmatic art, the book continues with a survey of early secular art and its influence on Buddhist expression. In dealing with Hindu art and architecture it points up especially the dynastic significance of the major monuments. It explains the special character of Indo-Muslim art, and the way it introduced new themes and interests. It then relates the achievements of the Rajput miniature painters to their complex aesthetic heritage.

The illustrations have been chosen, apart from a few essential masterpieces, mainly because they illustrate unfamiliar examples from the vast range of Indian art, because they show familiar pieces in an unfamiliar way or because they convey the special atmosphere of the Indian environment before Western life had much affected it.

Philip Rawson is Curator of the Gulbenkian Museum of Oriental Art in the University of Durham. He was previously Assistant Keeper of the Museum of Eastern Art (Ashmolean) of Oxford University and Lecturer at the School of Oriental and African Studies, London University. He has organized many exhibitions of Eastern art, the most recent of which was the Tantra exhibition at the Hayward Gallery, London. Previous publications include: *The Art of Drawing, Erotic Art of the East, Indian Painting, The Indian Sword, The Arts of South-East Asia, Japanese Buddhist Paintings, The Appreciation of Ceramics, Sexual Imagery in the Art of Primitive Peoples* and the Studio Vista Pictureback on *Indian Sculpture.*

INDIAN ART

Philip Rawson

Studio Vista|Dutton Pictureback

General Editor David Herbert

Front of jacket: Girl attendant, detail of ivory relief from toilet box, Begram, Afghanistan. *Musée Guimet, Paris.*

Back of jacket: Sculptured panel illustrating Vishnu legend, 7th century, Deogarh.

N 7301 . R35 1972

© Philip Rawson 1972
Designed by Ian Craig
Published in Great Britain by Studio Vista
Blue Star House, Highgate Hill, London N19
and in the USA by E. P. Dutton & Co., Inc.
201 Park Avenue South, New York, NY 10003
Set in 8D on 11pt Univers 689
Made and printed in Great Britain by
Richard Clay (The Chaucer Press) Ltd, Bungay, Suffolk

ISBN 0 289 70222 4 (paperback)
　　 0 289 70223 2 (hardback)

Contents

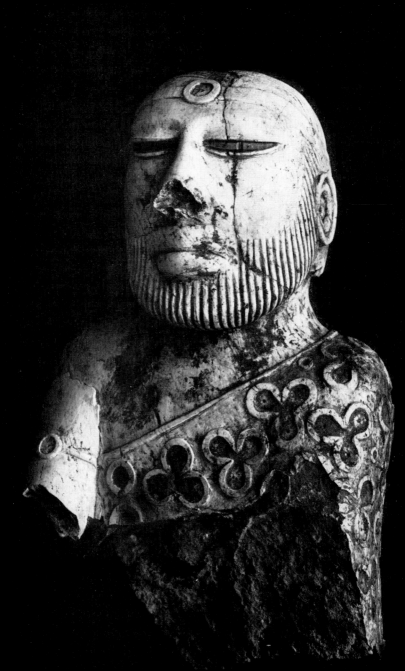

The Indus civilization

A vigorous civilization flourished in the Indus Valley between about 3000 and 1400 BC, roughly contemporary with the first eighteen dynasties of Ancient Egypt, and trading through the Persian Gulf with Mesopotamian Sumeria. Two of its large cities are known—Mohenjo-daro and Harappa. They had houses built on a regular grid of streets, public wells and drainage, and complexes of official buildings. All the surviving works of art of this civilization, however, are miniature, save for fine storage jars painted with emblematic designs. There are quantities of small terracottas, of stamp seals engraved in intaglio and a few tiny bronzes and stone-carvings.

We can only guess at the meaning of most of this art. Most beautiful, perhaps, is a miniature bronze girl with thin, stick-like limbs who holds a bowl against her thigh. A stout stone male torso strikingly resembles much later art; while stone figures and heads of solemn bearded men wrapped in what may be embroidered robes, perhaps, represent the members of a priestly college that governed the state. The seals and the impressed terracotta sealings made from them are the most informative works. The seals may have belonged to individuals, and been used to mark property and authenticate contracts; prism-shaped sealings were probably records of such contracts. The scenes they illustrate include a huge number of bulls, and there can be little doubt that there was a 'bull-cult' in the Indus Valley, somewhat resembling the earliest forms of the Mediterranean cult of Dionysus. There are scenes of bull-wrestling and bull-vaulting taking place before a head-icon on a pole (both customs that still survive among aboriginal peoples of India) and of bull sacrifice before a tree; one sealing from Harappa shows a human dancer wearing a bull's head. This may explain one of the small stone sculptures of a male dancer, which has a thick neck and dowel holes. For a separately

Image of an elder c. 2000 BC, stone, 4 in. high, from Mohenjo-daro

made bull's head was probably once attached to it. It may also
have had an erect phallus set into the appropriate socket; for
other seals represent an ithyphallic seated deity who wears a
horned headdress and is surrounded either by land or water
animals. This god may be a prototype of the later Hindu deity Shiva
Prajapati, who has similar characteristics. A similar deity on other
seals is adored by humans, by snakes, or appears in a tree-bower.
Other strange motives include a phallic-headed crocodile, a
female figure in sexual intercourse with one such beast, several
different animals sharing a common head and, most interesting,
a group of men who seem to be witnessing an animal sacrifice to
a horned deity within a tree. All these images suggest a complex
religious cult combining sacrifice, fertility and an anthropomorphic
nature deity.

Drawings of seals representing aspects of the bull cult, *c.* 2000 BC,
c. 2 in. long, stone, from Indus Valley

Drawing of seal representing female in intercourse with a phallic croco-
dile, *c.* 2000 BC, stone, from Harappa

The end of the Indus civilization seems to have come suddenly, after a period of decline. There follows a gap of nearly a thousand years in Indian art history, during which much of the great Vedic literature was composed by people known as 'the Aryans'. The rediscovery by eighteenth-century Europe of these hymns, commentaries and encyclopedias of folklore and metaphysics gave impetus to German romanticism, to the evolution of modern linguistics and religious ideas.

Early historical art

Indians have a vivid sense of the universal and the holy. This applies to natural objects and places as well as to people. The soil of India is covered with places where the divine shows itself either in some particular hallows, or by its association with holy men. Shrines may mark these holy places. They may be Hindu temples where sacred icons are lodged, Buddhist or Jain *stupas* in which

Lingam or phallic emblem, *c.* 1st century BC, stone, from Gudimallam, ▶ Madras

Yantra (folk cosmogram for meditation), 6 in. high, ink on paper, from Bengal

যোনিকুণ্ড ।

তন্ত্রসার ২য় ভাগ ১৩ পৃষ্ঠা ।

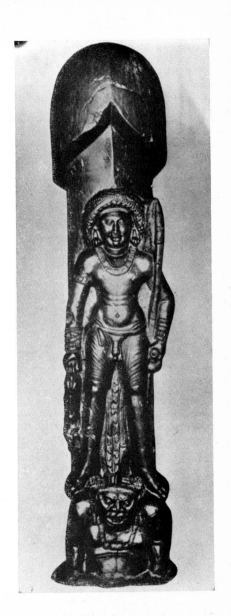

relics of Saints are enclosed, testimonies to royal power, or even Muslim tombs where saints are interred. And Indians always seek opportunities for contact with these sources of divine power in all sorts of ways, from bathing in the sacred Ganges to merely catching a glimpse of some charismatic person. Monumental art was always constructed as the outward expression of some such indwelling sanctity.

This feeling for the immediate intuition of profound identities going beyond the limits of everyday reality is reflected in the way space is handled in traditional art. Architecture, painting and sculpture make no attempt to match everyday perception. Instead they project a self-consistent enclosed world of their own. This world is subdivided schematically from the outside in. Hindu temples or Tantric diagrams, each on their own scale, claim to define inclusively the entire manifested cosmos. The representational arts define its lower and more limited aspects. Architectural and sculptural volumes projecting from the volumes of a building are given massive convex physical presence; pictorial space is subdivided from the frame inwards as progressively smaller areas, each of which is an inclusive and generalized form. Individual irregularity is irrelevant.

This way of feeling and this conception of art are not fully developed in the earliest historical art we know. The preoccupation with an imagery of totally enclosed systems was probably produced as part of the effort sustained by Brahminized Indian culture after about AD 100 to coin an image of man in a world and society which had an absolute value. The arts which served this image worked through canonical general types and patterns, with repetitive schemes of colour and design from which all suggestion of uniqueness, time and change are exiled. It is no accident that the only real portraiture and landscape art in India was made under the foreign inspirations of Islam and Europe. Traditional Indian art can thus only be discussed in terms of broad styles, not of individual idioms and achievements; though it may be that one day the work of particular masters may be identified.

The devastating climate and history of India have left only scattered fragments of early historical art. We must not be deceived by the fact that it is religious monumental art which has

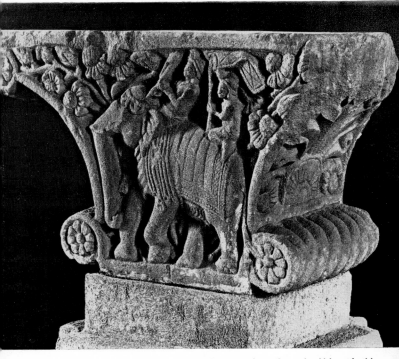

Capital from a pillar, *c.* 150 BC, stone, from Sarnath. Although this comes from a religious site similar capitals were used in palaces. *Indian Museum, Calcutta*

survived best. During the later part of the first millennium BC all the arts flourished in the northern river-basins. Buddhism and Jainism were then growing and spreading, and their early literature describes an architecture which archaeological research has confirmed in detail. It included palaces with many stories, colonnades, balconies, arches, gateways and pavilions. By about 100 BC there must also have been a characteristic pictorial art fully fledged in all the great cities of northern India. But in these walled cities, such as Kaushambi, beautiful Rajgir, Kapilavastu

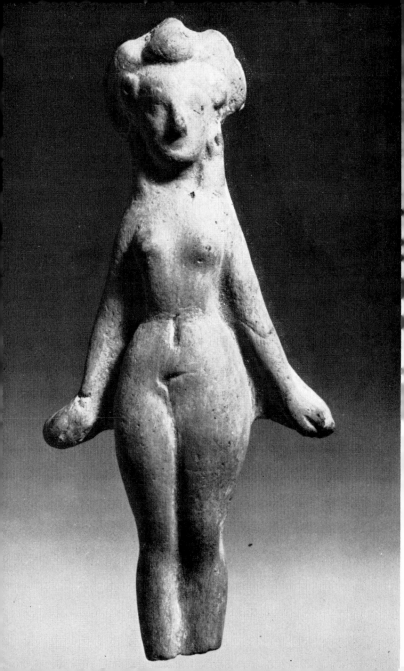

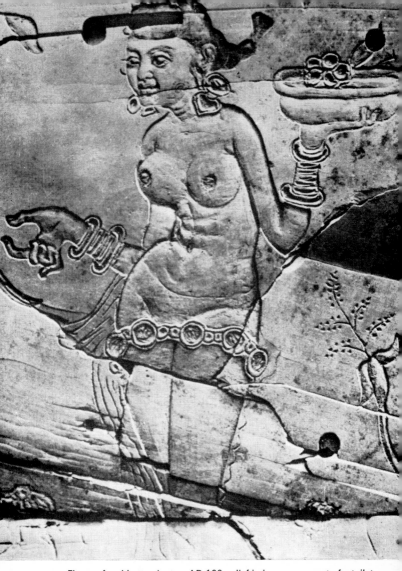

Figure of a girl attendant, *c.* AD 100, relief in ivory, once part of a toilet box, from Begram, Afghanistan. *Musée Guimet, Paris*

◀ Miniature figure, *c.* 100 BC, terracotta, from the Ganges Valley. *Victoria and Albert Museum, London*

the Buddha's birthplace, Chandraketugarh in Bengal, or Patali-putra (old Patna), all the capitals of local dynasties of kings, the inhabitants must have patronized relatively sophisticated arts of painting, music and the dance. We know that the kings maintained public pleasure-gardens around their cities (the Buddha was born in one) and we know that skilled courtesans were honoured. From the third century BC onward numerous little terracotta sculptures were made, in relief and in the round, some as personal ornaments, which depict girl dancers, lovemaking, pleasure parties and animals. These secular subjects refer to personal enjoyment without any ideological commitment. We hear in early literature of decorated public buildings, such as baths; and even of a courtesan who kept a hall painted with scenes conveying various emotions, and judged the characters of her clients by their reaction to the paintings. Indeed figurative painted decoration always seems to have been usual in those millions of India's wooden houses which the climate has totally destroyed. Many early miniature sculptures are devoted to the highly erotic treat-ment of women. Chief of these are the ivories from Pompeii (before AD 79, probably *c.* AD 10) and Begram (first–second century AD). They all suggest that an erotically-flavoured style of secular art was in full spate soon after the birth of Christ. Secular woodcarving was probably a flourishing art as well. The sweet, erotic and humane handling of humanity and nature in the early religious art is therefore best explained if we realize that it was created by professional artists who worked normally in their own sensuous styles in impermanent materials for secular patrons, and were called in to decorate religious monuments from time to time.

Buddhist art

The earliest stone sculptures of historical India are probably the sandstone victory pillars set up by the Mauryan emperors in various parts of their extensive empire, some of which were inscribed with moral edicts by Ashoka Maurya (d. *c.* 232 BC). Some he set up and inscribed himself were at religious sites—for Ashoka may have become a Buddhist. His pillar at Sarnath, where the Buddha preached his first sermon, a site which became a dynastic shrine for the Mauryas, is famous. Each of these pillars is a smooth, baseless shaft of sandstone, crowned by a capital in animal form—lion, bull, elephant, horse—supported above a bell-shaped cushion representing down-turned lotus petals. The animals and other emblems embody a cosmic symbolism related both to religion and to kingship. The whole surface is polished—perhaps in emulation of the polished sandstone columns at Achaemenid Persepolis. Sculptural motifs on these columns and other early fragments may remotely echo those of imperial Persepolis, known most likely by hearsay: the lion heads, rosettes and lotus petals are all Persepolitan in flavour. Also found at Sarnath were fragments of Mauryan stone figure-sculpture, heads and seated figures probably from dynastic dedicatory images.

The series of early caves begins in the Mauryan epoch with two polished caves in the Barabar hills made as rain-shelters for monks; and with a cave (no. 13) at Ajanta near Bombay, perhaps polished by intention rather than mere use. These caves were the first of many offering cool refuge from the Indian sun to be chiselled from the living rock—a characteristic Indian activity. Between about 200 BC and AD 200 Buddhist preaching-hall caves (*chaityas*) were cut in the volcanic trap of the Western Ghats in the Deccan. They follow a pattern similar to a Christian basilica, with a columned, barrel-vaulted nave, two aisles and (usually) a semicircular ambulatory. At the inner end stands a rock-cut *stupa*, and the outer end is opened by a huge horseshoe arch, trellised, to let in the light and air. The whole *chaitya* thus

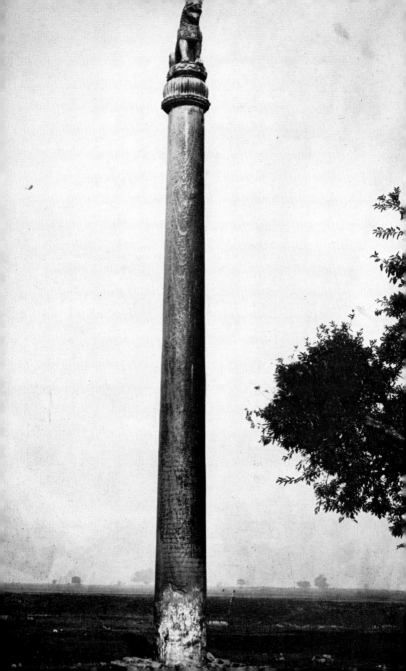

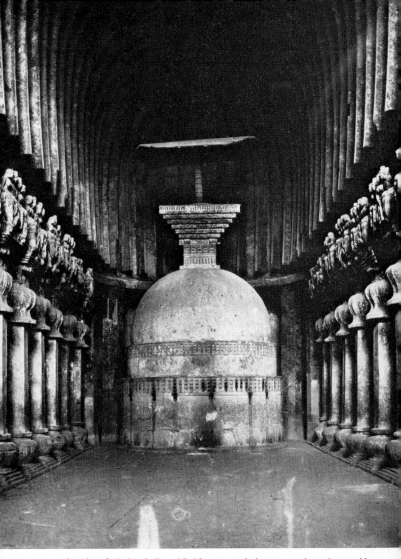

Interior of *chaitya* hall, *c.* AD 10, cave entirely man-made and carved in rock, at Karle, Bombay

Monolithic pillar crowned by a lion capital, 3rd century BC, polished sandstone, with an inscription of Ashoka, at Lauriya Nandangarh in North Bihar

combines into one architectural unit the aligned *stupa* and structural hall of the oldest Buddhist sites. The earlier ones (e.g. Bhaja) were completed in wood with roof-ribs, balconies and lattices; the later ones (e.g. Karle, Kanheri) were stone sculptures of complete wooden buildings, with imitation joist-ends, brackets and railings, their pillar-capitals decorated with beautiful jewelled couples riding addorsed animals. We find here what became a typical Indian attitude to stone architecture—to treat it as a sculpture of a building. For these later *chaitya* caves are cut with façades reproducing in full detail those of wooden palaces; there are even figures of girls and dancers framed in the balcony windows. On the façades of Karle and Kanheri are colossal rock-cut reliefs of opulent couples, the men and women standing with arms around each other. The image is clear. The Buddhist shrine is 'interpreted' as a celestial palace, modelled on those of human kings which we find sculptured in narrative reliefs. In the rock near these preaching halls small living-cells were gradually added

East gateway (representing Buddhist legends and symbols) of *stupa* I, *c.* AD 20, at Sanchi, Bhopal. The spirals at the ends of the lintels suggest ▶ the rolled ends of a story-scroll.

Coping stone representing Buddhist legends in the meander of a wish-granting tree, 2nd century BC, sandstone, from Barhut, Bihar. *Indian Museum, Calcutta*

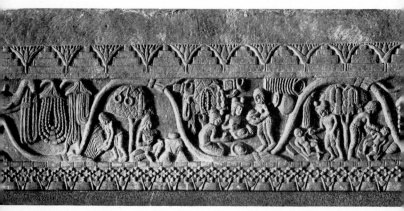

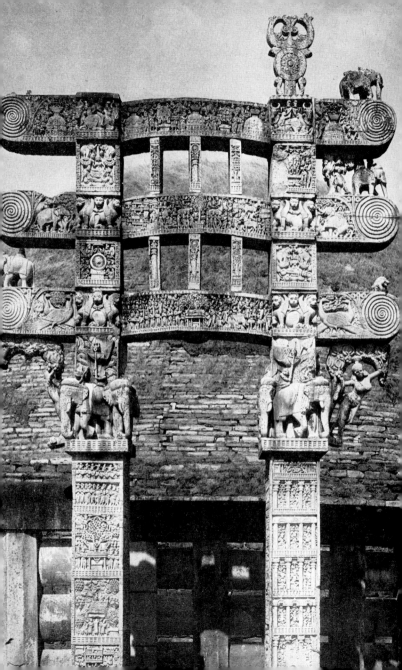

for resident monks. And at Ajanta these proliferated, with bigger preaching halls, to form a complete monastery.

The Buddha (d. *c.* 489 BC) was an ascetic who taught a doctrine which would enable every man to see a whole Truth beyond the limiting agitation of his urges, dreads and mental constructs. He was not a god, but a human example who attained that Nirvana. And so the early Buddhist shrine is really a place for honouring relics, for preaching and worshipping only the Truth. The early shrines, faced with stone, built probably by local dynasties, focused on the structure called the *stupa*. This is a domed mound, near the summit of which is inset a chamber containing relics of the Buddha or Buddhist saints, thus raising them high, to honour them. A raised pathway encircled the dome so that visitors could perform ritual perambulation of the relics. The summit was crowned with a small enclosure inside which were set

Part of a relief representing the adoration of the Buddha, symbolized by his footprints, 3rd century AD, white limestone, from Amaravati, Andhra. *Madras Museum*

up tiers of honorific umbrellas. A railing with one or more gates enclosed the structure, and the preaching hall, perhaps with a pillar, was aligned with it. The *stupa* itself quickly became a sacred emblem for the idea of Nirvana. The earliest *stupas* were plain; but sculptured reliefs were often added later. The railing of Barhut (second century BC) was richly sculptured with symbolic reliefs in a somewhat hieratic style. They suggest that Buddhism is a 'wish-granting tree', satisfying all desires. The gateways of Sanchi I (*c.* 20 BC–AD 20) were carved with bands and panels of narrative relief of Buddhist legend, reminiscent of the story scrolls still popular today, in a style close to that of the earliest wall paintings in Cave 10 at Ajanta. At Bodhgaya an early railing and throne have survived; they probably once marked the original site where the Buddha achieved that enlightenment on which his whole teaching is based.

In the eastern Deccan, an important style of *stupa* sculpture flourished between about AD 50 and 300, although its beginnings probably go back to the second century BC. At a number of Buddhist sites, of which the most famous are Amaravati and Nagarjunakonda, the *stupas* and their railings were ornamented with lavish relief sculpture in a white stratified limestone. The carving of rosettes and foliage panels was some of the most distinguished and elaborate in India. The Buddhist scenes are crowded with idealized and sensuous figures, in a style which must be the direct ancestor of the third–seventh-century paintings at Ajanta across the peninsula. The relief successfully creates a sense of pictorial depth by organizing the overlapping of the figures and the placing of their feet on a 'floor' which rises into the distance. This suggests most strongly that the work of the sculptors formed part of a tradition in which painting also played a major role.

At the earlier northern sites the Buddha was not physically represented even in scenes in which he played a part. Instead, his presence was indicated by a symbol such as a cushion on a throne or a pair of footprints. At the Andhra sites this custom was only occasionally preserved. In the later third century AD, life-size sculptures of the Buddha in the full-round were cut, to stand at the entrances to the *stupa* enclosures. A number of reliefs

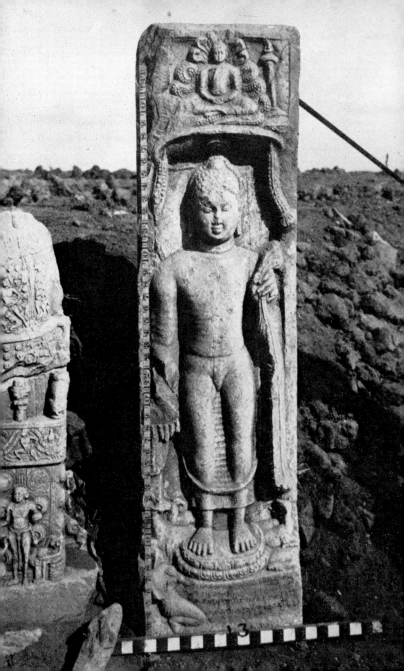

illustrate *stupas* that have such life-size figures *in situ*. The Andhra Buddha-type wears a heavy robe, with string-like lines, smoothly following each other, to indicate the folds. By the fourth century AD this type seems to have made its way into South-east Asia. Since Buddhism was very much a merchant's religion, where trade went during the Buddhist centuries, monasteries and Buddhist art naturally followed.

The image of man that the earliest Buddhist art presents is conventional but recognizably human. Since this art was directly derived from those secular traditions dealing with everyday pleasures it represents beings on a human scale. The participants in the legendary scenes from Buddhist literature which are carved on the railings, caves and *stupas* of the early sites up to about AD 300, and those painted in the earlier caves of Ajanta, are intended to be men, not cosmic deities, although individuality is never clearly marked. They occupy a world which never claims to be more than the everyday world of the recent legendary past. The ground the Buddha walked on as a man was the familiar earth of the sacred sites; the cities and roads he visited still survived. These relief sculptures invite the spectator to look at them as reflections from his own familiar life. Their buildings, gateways and trees are symbols for a contingent world. The only symbol for transcendence or mystical doctrine is the absence of the Buddha. When he does begin to appear in type-images, in the late first century AD at Mathura, and in the second century at the Andhra sites and in Gandhara, we must recognize the first appearance of a new way of thinking. There are on all the early monuments, it is true, figures which represent male and female godlings—like the so-called Yakshas and Yakshis who decorate the pillars and gates at Barhut, Sanchi and Mathura, pressed into service as attendants at the 'palace of true [Buddhist] doctrine'. But such minor divinities were part of the everyday world of village India. They lived in trees and tanks on familiar terms with humans. They still do. The only larger-than-life figures are those cut on the rock-façades of some of the caves—notably Karle—and

Buddha of Andhra type, *c*. AD 300, white limestone, from Gummadi-durru, Andhra

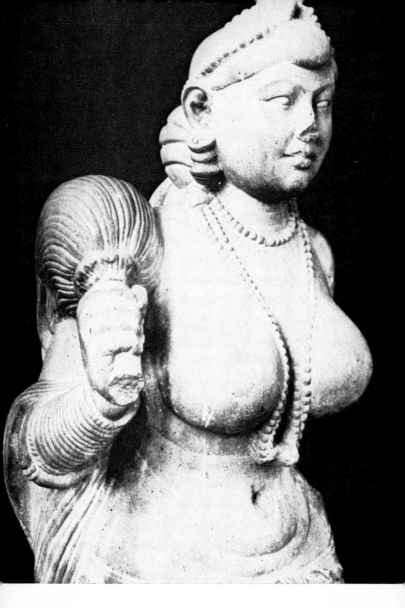

Dedicatory female image, 1st century AD, colossal, polished sandstone, from Didarganj

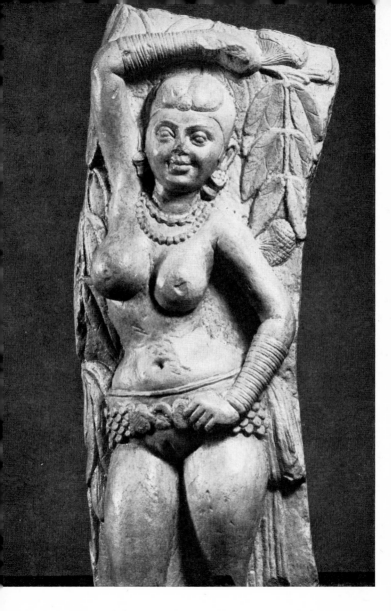

Female bracket figure, *c.* AD 100, red sandstone, from Mathura.
Victoria and Albert Museum, London

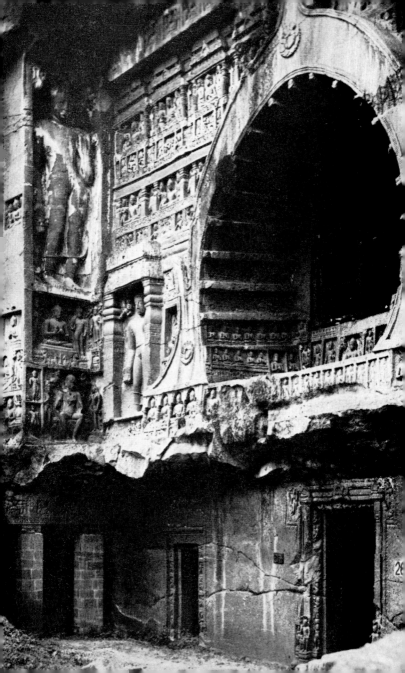

a few free-standing dedicatory figures, which may have been cut by the guild of Mauryan dynastic sculptors (*c.* 250 BC–AD 20).

Mathura was a city where for at least six centuries (second century BC to *c.* AD 500) sculpture of all kinds and sizes, Buddhist, Jain and Hindu, was carved in the characteristic pink sandstone and exported all over north India. There the railing pillars for shrines during the first century AD began to be carved in deep and emphatic relief, and to include extremely erotic female figures. The girls pose with mirrors, wash under waterfalls or feed birds, all their charms unashamedly on display. These are the Apsarases, heavenly girls with whom the Indian imagination filled its heaven. Their love is the reward of the hero and the saint; they appear in the classical epic poems. Later on they populate the whole fabric of Hindu temples; their presence confirms that the image of the shrine was an earthly analogue of heaven. Their function was to harness human desire to religious ends. But the sensuous style in which they are carved originates in the world of secular eroticism, and stimulates a desire to caress, never a merely ascetic piety. Indeed one of the leading characteristics of Indian sculpture is its appeal to the sense of touch, inviting the hand, and evoking memories of rounded surfaces of flesh which have been exiled from so much of the world's 'religious' art.

An interesting aspect of the art of Mathura is its very early imitation (perhaps by the end of the first century AD) of Graeco-Roman motifs. Small classical sculptures traded-in along the Indus, such as toilet palettes, lamps or terracottas from Hellenistic Memphis or Alexandria, may have provided the patterns for the Indian Hercules, and for the sculptures of drinking parties on classical models which were carved at Mathura. They passed into the repertoire of Indian art. Even earlier, about 100 BC, a sculptor on the gate of Sanchi II had imitated an Achaemenid ivory-carving of a warrior confronting a lion. And this ancient motif, changed and developed, became a standard item of Hindu iconography.

By about AD 100 the carvers of Mathura had developed what was probably the earliest native pattern for the seated Buddha figure, which was meant not simply to represent a character in a

legend, but to serve as a focus for adoration. Mathura also developed the basic type of standing human Bodhisattva, probably derived from the free-standing dynastic colossal sculptures, under Mediterranean influence. An early Mathura stone relief shows a pair of them standing at the approach to a *stupa*. The royal Bodhisattva type of Mathura, along with associated types of Hindu deities developed by about AD 150, had been transported overseas by the fifth century AD, into the distant river valleys of Indo-China.

All these relics of religious sculptural tradition can give us some idea of what the contemporary secular art must have been like. The styles would have been based on well-established types, executed swiftly but imbued with genuine feeling, probably by guilds of artists. We know nothing of any Mathura painting, but we must assume that such an art existed. Without the chance survival of wall paintings at Ajanta and fragments at a handful of other sites, we should know nothing of the magnificent traditions of painting in India between about 200 BC and AD 500 which they represent. We should never have been able to imagine the richness of the Ajanta styles from the evidence of contemporary architecture and stone carving.

Ajanta is a rock-cut Buddhist monastery of twenty-seven caves, four of which are preaching halls, the rest living caves with cells opening from a hall or verandah, excavated between the Mauryan epoch and the sixth century AD. Six of the caves contain substantial fragments of wall painting on plaster. The pigments were supplied by nodules of metallic oxides from the excavated detritus of the rock itself, ground and mixed with a gum, perhaps a plant juice. The oldest paintings in Cave 10 are about the age of the Sanchi gateways, *c.* 20 BC; the latest may be fifth or sixth century AD. The earliest mainly represent Buddhist legends about previous incarnations of the Buddha, in a modest and humane style. The later emphasize pure icons of cosmic principles, Buddhas and compassionate Bodhisattvas, which parallel the large iconic sculptures cut in rock on the façades and in the inner cells. Ceilings are decorated with gorgeous floral and animal fantasies, and the inhabitants of the heavens appear, including flying Gandharvas and the divinely beautiful Apsarases. The

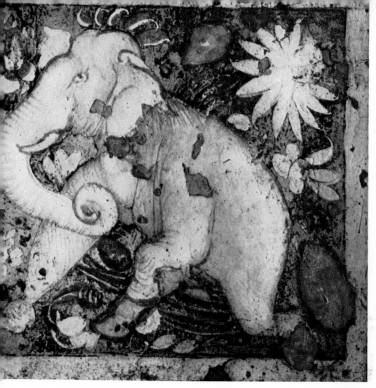

Elephant in a lotus pond. Painting from cave, l5th century AD, plant juice and pigment on plaster, at Ajanta

narrative scenes contain elaborate architecture, some landscapes, and are especially remarkable for the extremely sexual flavour of much of the figure painting—quite 'unsuitable' for the home of an ascetic order whose members were forbidden even to look at a living woman. There is even one scene of a dancing girl painted in an inner cell. At Bagh, in Cave 4, there are also a few scraps of wall painting representing dancing girls surrounding a male figure dancing in a fantastic costume. The styles of these works are always consistent with contemporary or earlier Buddhist sculptures from around the Deccan, as at Sanchi, Kanheri and Amaravati. The sensually 'inflated' style is more aptly used in the few scraps of surviving painting on the rock of Sihagiri in

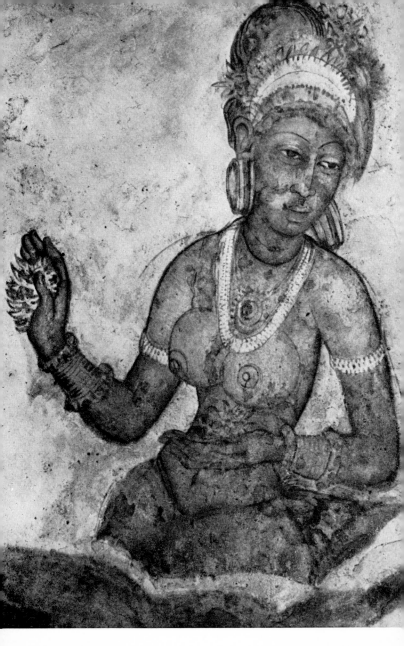

Painting of an Apsaras, *c.* AD 490, plant juice and pigment on plaster, at Sihagiri, Ceylon

Ceylon. These are the remains of a scheme executed on the inner wall of a rock pathway, probably just before AD 500. All represent Apsarases; these paragons of celestial erotic appeal bear offerings up the pathway to a king whose palace once crowned the summit.

Sometime between the seventh and ninth centuries AD the Jain caves of Sittanavasal in the southern Deccan were also decorated with paintings. Their style serves as a link between the style of the last paintings at Ajanta and the Cola paintings at Tanjore of *c.* AD 1000. On the pillars of the façade are elegant figures of Apsarases, and on the ceiling of a verandah is a large composition representing a lotus-filled pool, probably a paradise, in which animals play and men pluck the flowers. The style is softer and blander than the late Ajanta work. Once again we must consider these paintings as the sole survivors of what literary descriptions suggest was a flourishing and widespread art.

Abundant literary evidence, including the famous erotic manual the *Kamasutra,* makes it quite clear that as well as wall painting, small-scale portable painting was also very common. It was even expected of a cultured man-about-town that he should be able to paint the likeness of his lady-love, though we must not imagine that a 'likeness' in this sense would have been a portrait in our sense of the word. No surviving art suggests that the concept of the true portrait existed then in India. Most probably such a likeness would enumerate correctly the garments and jewels a girl wore and perhaps, at most, hint at outstanding physical characteristics, such as large or small breasts, by slight modifications in an idealized type-image.

We must assume that unknown styles of painting existed at this period in other parts of India, especially in the north-west. Here it must have formed part of the wave of artistic activity in the region called Gandhara, which stretched from the valley of the upper Indus river into the valley of the Kabul river in modern Afghanistan. During the first century AD, after a history of Greek–Parthian conflict, this part of India came under the domination of the Kushans, a nomadic tribal people from the borders of China. Their kings patronized several religions, their merchants Buddhism in particular. About AD 120 direct overland trade routes between China and the Roman Mediterranean were properly opened, via

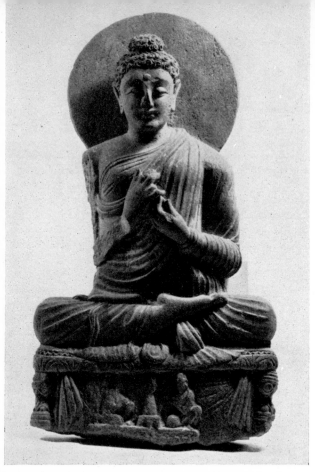

Buddha figure in the preaching posture, *c.* AD 300, carved schist, from Gandhara. *Museum of Eastern Art, Oxford*

Khotan and the Pamirs. Gandhara's Buddhist merchants became very wealthy, and everywhere huge monasteries sprang up, encrusted with sculpture in stone and stucco, containing numbers of smaller bronze images. The style was deeply tinged with influence from the eastern Mediterranean. Buddhist figures wore togas; Graeco-Roman deities and putti, even scenes from Greek poetry, appear as ornaments on Buddhist buildings; this work was probably based on such prototypes as plaster patterns and metalwork turned out by the workshops of Alexandria, some of

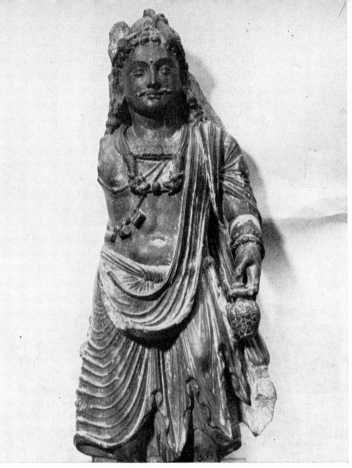

Bodhisattva image, late 2nd century AD, carved schist, from Gandhara. *Museum of Eastern Art, Oxford*

which were among the finds at Begram. Related styles survived in the north-western valleys and in Fondukistan until the sixth, perhaps the seventh century AD. It lived still longer, but modified by Gupta art, in Kashmir.

This epoch of Indian art history was most important for its effect abroad. In the monasteries of India a form of Buddhism developed, the Mahayana, which embodied an ideology of salvation by compassionate Bodhisattvas alongside an imagery of the all-embracing Buddha-nature as transcendent and immanent at

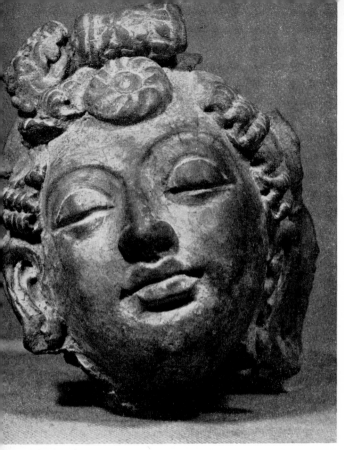

Ecstatic head, derived from a late Classical type, 5th century AD, terra-cotta, from Gandhara region. *Victoria and Albert Museum, London*

Figure of the Buddha, offering protection. Mid 4th century AD, sandstone from Mankuwar. The inscription suggests that it was dedicated in ▶ the reign of Kumaragupta.

once. Gradually, first at Mathura during the second century AD and then elsewhere by the fourth century, the Buddha came to be represented as a colossal golden 'Body of Glory' endowed with many symbolic attributes which point beyond human form towards unrepresentable Truth.

In the regions of northern India where the Mahayana flourished

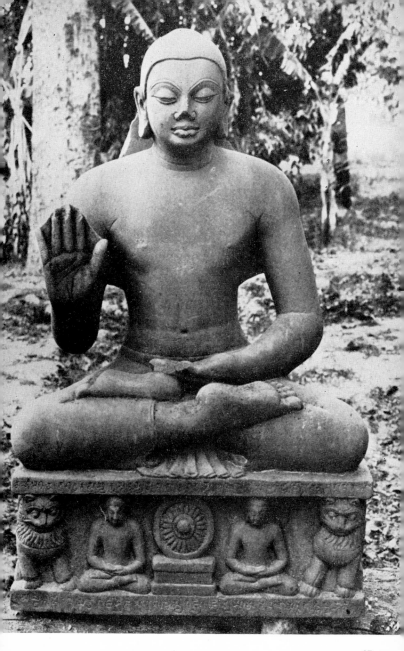

such icons of the body of glory must once have existed wherever Buddhism flourished until it was finally expunged in the twelfth century. This conception spread to all the Buddhist countries of South Asia, where it still persists. Two of the most influential historical instances are the Buddha images, dating from the fourth century, carved in a cliff-face at Bamiyan in Afghanistan. The Bodhisattva saviour figure of the Mahayana, who had renounced his own Nirvana until he should have led all living creatures to salvation, is always depicted with an affectionate warmth which images of the Buddha himself may lack.

The types of art formed in Gandhara were carried, during the second—fourth centuries AD, through Khotan, across Central Asia into China, and somewhat later into Korea and Japan. Central Asian art derived from Gandharan art accompanied missionary monks with their texts, and supplied these regions with their patterns for figure sculpture and painting, characterized by looped and rope-like folds of heavy drapery. By about AD 600 Chinese pilgrims made direct contact with the true home of Buddhism in Bihar, and learned fresh patterns. But the original Gandharan impulse is still not dead in the Far East today. The Chinese and Japanese Buddhist pagoda was probably developed from a native Chinese type of wooden tower modified in emulation of the colossal tiers of gilded umbrellas which once crowned the tall *stupas* of north-western India.

At the flourishing oasis towns along the desert trade-routes of Central Asia Buddhist monasteries were established. Fragments of their ruins have been excavated. Not much of the plaster and wooden sculpture survives. But many paintings on plaster and wooden panels are known. Generally the style is marked by wiry loops and angular patterns, with colours that are bright without being passionate. In fact there are probably traces of Byzantine influence in some later examples, for the style lasted until about AD 850—longer still at a few sites in Mongolia.

In India Mahayana Buddhist art flourished in Bihar and Bengal. Sarnath, the site where the Buddha first preached his doctrine of

(Pps 40–41) Buddhist figures carved in a cave, *c.* AD 700, stone, at Nasik

Torso of a Bodhisattva, 9th century AD (?), sandstone, from Sanchi.
Victoria and Albert Museum, London

Carved facing of the Dhamekh *stupa*, 7th century AD, stone, at Sarnath

salvation, again became a major artistic centre under the patronage of the Gupta and later emperors (*c.* 320–620). This was probably the period when a great revival of Sanskrit literature took place at court, and plays and poems were produced that have become world classics. For some two hundred years after about AD 400 workshops produced many Buddhist sandstone icons in a smooth, sweet and somewhat febrile Sarnath style. They have broad, flat, stone haloes adorned with careful floral scrollwork in relief. But the perfectionist surface finish often hides routine formal conceptions. This bland art was no doubt once enlivened by colour—for most major Indian sculpture was once painted. But perhaps more interesting are the large, standing Buddhas cut in the pink sandstone of Mathura; their suave, linear drapery, in exceedingly shallow relief, loops regularly across the smoothed-out volumes of the body.

After the Gupta dynasty lost its empire, and India had been invaded by the White Huns in the second half of the fifth century, a number of lesser kingdoms continued to patronize styles of Buddhist art derived from Gupta traditions, both at the principal

centres and on the fringes of the old empire. For a short time under King Harsha (606–7) the unity of northern India was re-established.

During the post-Gupta centuries in north India much Buddhist art was produced; most of what survives shows that the art gradually became stereotyped, and interacted with contemporary Hindu styles. Two outstanding pieces of sculpture are the huge bronze Buddha, cast by a complex process, from Sultanganj, now in Birmingham, England; and the stone Bodhisattva torso from Sanchi, in the Victoria and Albert Museum, London, which follows a softly rounded type, posed with one hip thrust out, that powerfully influenced the Bodhisattvas carved in China in the later T'ang dynasty. In the Deccan, as well as in the north, many small-scale Buddhist and a few Brahmanical bronzes were cast, which follow, broadly speaking, types fixed during the Gupta era; though, of course, clear stylistic distinctions between work of different ages and places can be drawn by the study of the minutiae of execution. In the Deccan also Buddhist caves continued to be excavated until about 800 AD, notably at Ellora and Nasik.

Most of the many monuments of Buddhist architecture belonging to the very early Middle Ages have vanished. What survives is best represented by two major monuments. The first, the Dhamekh *stupa* at Sarnath (seventh century) is a tall tower resembling the spire of the Hindu temple, and decorated with bands of patterned and incised foliate ornament, from which almost all recollection of the structural *stupa* has gone. The second is the huge university monastery of Nalanda founded by the Guptas, whose splendour was described by the Chinese pilgrim Hsuan T'sang, and has now been excavated. Here, and at the companion university of Vikramashila (founded by Dharmapala), the system of Buddhist scholasticism known as Vajrayana, or Tantric Buddhism, was developed. Its doctrines incorporated medicine and magic, and it evolved a complicated system of diagrammatic iconography which represents visually a vast range of divine principles and their interrelationships. This type of Buddhism was transplanted from these universities into Tibet, and reached China, Japan, Burma, Siam and Indonesia.

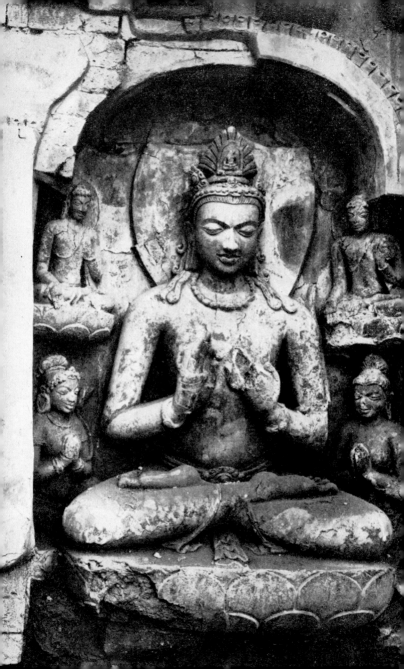

Figure of the preaching royal Bodhisattva, 8th century AD (?), stucco, on a *stupa* at Nalanda

Nalanda was, apparently, a crowded complex of courts, halls and cells, today almost without ornament; although to judge by what remains elsewhere, there were once many wall paintings on plaster, and stucco sculptures. The shrines contained many fine small bronze figures of Buddhas and Bodhisattvas. It flowered in the high Pala period (ninth–tenth century), expanding vastly; and some of its buildings were then ornamented with multiple niches and pilasters. In this they resemble the pyramidal tiered shrine standing today at Bodhgaya, restored in the twelfth century by a Buddhist king of Burma.

During the Pala period a very large number of Buddhist sculptured relief icons were made; many larger ones are in a hard, glossy black slate; smaller ones, in bronze, may illustrate the divine principles of the Vajrayana. Except for the plinths at

The Mahabodhi temple, 4th–12th centuries AD, at Bodhgaya, marking the site of the Buddha's enlightenment

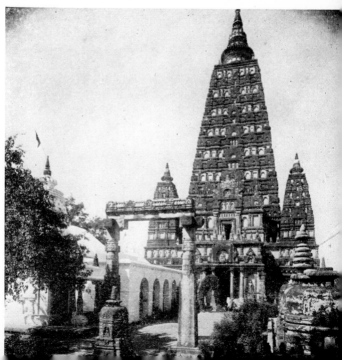

Manuscript cover, *c.* 1100, gouache on lime-surfaced wood, from Bengal

Somapura (founded by Devapala) and Mainmati, with their fine terracotta sculptured panels, the brick temples for which these icons were made have mostly vanished, though it is probable that they were widely imitated in Tibet and South-east Asia (e.g. at Pagan and Ayuthaya). It is more than likely that the royal temples associated with the Pala monasteries provided a setting in which sculptures could be arranged so as to create architectural diagrams of transcendental philosophy. Certainly Somapura, a cruciform temple on its high plinth ringed with cells, was designed as such. This was certainly also done in the contemporary temples of Java which do stand, and have close religious and stylistic links with those of north-eastern India. Many Pala stone sculptures can be seen in the museums of India and the West. Since they symbolized abstract concepts as focal points for meditation, it is not surprising that some should suffer from a slight hardness of touch. But many are extremely beautiful, the female figures often being carved with a splendid sensual competence.

In parts of Bengal similar icons were carved under the twelfth-century Sena kings to serve a similarly scholastic form of Hinduism.

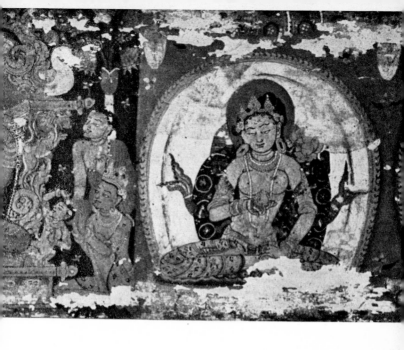

Their temples, too, have vanished, though again they were widely imitated in South-east Asia. A number of beautifully illuminated palm-leaf manuscripts of Buddhist texts are preserved in museums in India and the West, the style of which is closely dependent on the sculptures, while at Udayagiri in Orissa there are many rock-cut Buddhist images associated with caves, which are in a version of the Pala style.

The historical importance of the Pala school—only a few of its chief sites have been mentioned—is immense. During that epoch the pilgrims poured into Bihar and Bengal from all parts of Asia so that the Pala school supplied many other countries with sacred patterns of Buddhist art. First: the great Buddha icon (now lost) of Pala type at Bodhgaya, the fountainhead of Buddhism, at the very spot where the Buddha attained his enlightenment, was copied in thousands of small memento-sculptures, stone or terracotta, and carried to all countries of South-east Asia. Second: the brick buildings of Pala Bihar were re-created in the Burmese capital Pagan, where during the eleventh to twelfth century, literally hundreds of shrines were built, decorated in

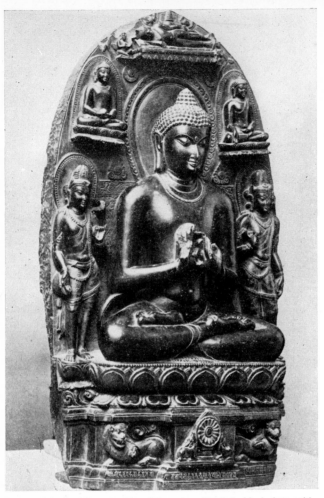

Statue of the Buddha preaching, 9th century AD, Pala, black slate, said to have been found at Sarnath

terracotta by sculptors and adorned by painters who may even have come from eastern India. Some of this work survives. Third : there can be little doubt that certain buildings in distant Cambodia were based on eastern Indian Pala types. And fourth : the whole recent art of Nepal and Tibet was based on Tantric Pala art.

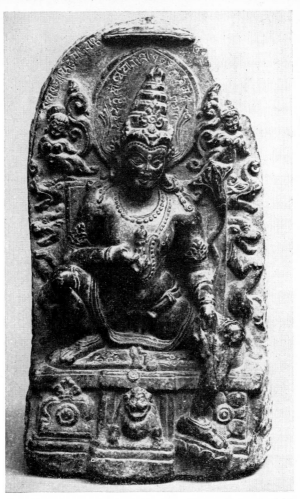

Sculpture of a Bodhisattva holding an emblem of Buddhist truth, *c.* AD 900, black stone, from Bihar. *Victoria and Albert Museum, London*

In 1196 a party of Moslem horsemen slaughtered the last Pala king in his palace at the centre of his peaceful kingdom. The great Buddhist universities of Nalanda and Vikramashila were looted and destroyed. Many monks escaped to the north. Buddhism was expunged from India.

Hindu art

Although Hinduism is the oldest surviving religion in India, Hindu art does not appear first on the historical scene. In a sense the godlings incorporated into Buddhist *stupas* are Hindu. For basic Hinduism recognizes the divine in many forms. But fully-developed Hindu art is associated with the temple, and the figures in its sculpture do not spring from the same assumptions as do those in Buddhist art.

Kingship and the Hindu concept of divinity were interwoven by quite early times. The gods of early Hindu sculpture were not the old gods of the Brahmins and the Veda; the Vedic sacrifice had no need of permanent shrines or images, but deities such as Vishnu, Shiva and Surya had a *raison d'être* which was not priestly but dynastic. It is probable that, in earlier historical centuries, kings used to dedicate images of themselves at chosen shrines and that these images came to be worshipped by their subjects. A Mathura relief of the second century BC illustrates a personage offering such an image. Probably by about 250 AD images of king and god had ceased to be distinct. The king, who administered divine law to his people, was identified with his own patron deity, and buttressed his power by building dynastic temples in which that transcendent patronage was displayed. The deity who was each king's celestial identity resided for ritual purposes in the main icon in his own temple.

The earliest surviving Hindu sculptures serving the royal cult were carved at Mathura during the second to fourth centuries AD. Most represent Shiva, Vishnu or Surya. And it is more than likely that Hindu art as we know it was bred in the north-west. For life-size portrait-images of Kushan kings had been carved during the first and second centuries AD; they look odd because they are 'blown up' from coin devices. Unfortunately we do not know any of the temples which housed these icons.

Figurine of the Hindu god Brahma, *c*. AD 500, bronze, from Mirpur Khas, Sind

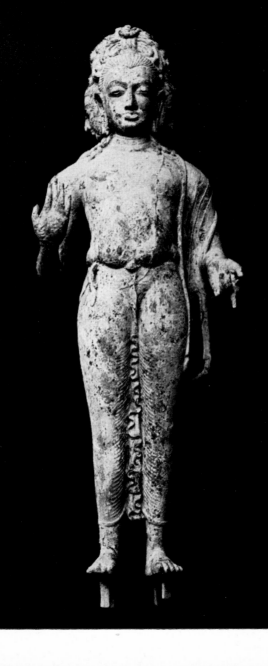

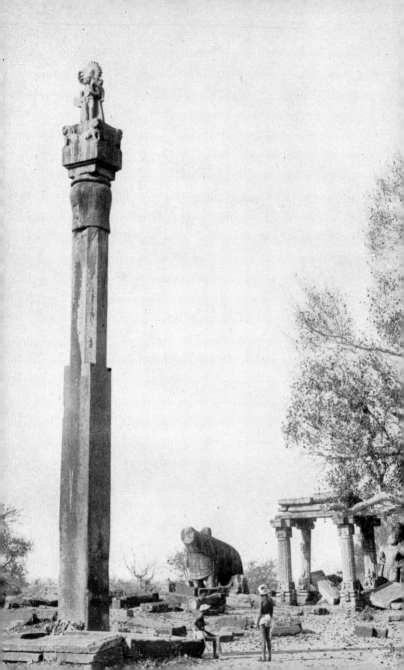

Group of dynastic monuments, with Vishnu images, early 5th AD, Gupta, stone, at Eran

Pillar of temple, 8th century AD, stone, at Alampur. The decorat derived from jewelry and sprouting foliage.

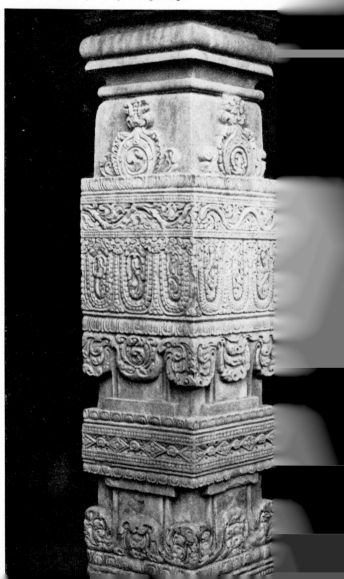

There are, however, later royal capital cities surviving elsewhere which contain numerous temples. For it is probable that each successive king of a dynasty built his own, often trying to outdo his predecessors. When Buddhism converted its shrines into celestial palaces of the invisible Truth, by decorating them with all the paraphernalia of the palace of an earthly king, this was only a device. Hinduism, however, allowed the ultimate 'Ground of Being' a face and form; it could be glimpsed in the more-than-human king and queen, in their sculptured type-images and in representations of the legends of the chosen patron-god. Royalty and divinity became metaphors for each other. Systems of law, administration, statecraft and social organization administered by court Brahmins and canonized in classic Sanskrit texts, were part of the functional apparatus of royalty. It was these which made Indian ideas of divine kingship so welcome everywhere; for example, in previously tribal regions of South-east Asia. Hindu temples thus symbolized in essence the wealth, splendour and power appropriate both to the god and to the king, evolving in step with Hindu society. Figurative art lost its earlier independence as the social significance of the individual waned and Brahmanical religion realized its claim to rationalize the whole of life. Medieval Hinduism came to see man as a mere ripple on an ocean of Reality vast beyond imagining. Classical Hindu sculpture and painting therefore concern themselves only with gods and celestial beings, including a few kings, heroes and human teachers who became virtually divine. The humane legend and secular hedonism of the old heroic epics was absorbed into the royal-religious world-image, as an element in the cult. At the same time it became possible to look on every fresh temple as a reaffirmation and strengthening of the metaphysical system it represented. Hindu temples could thus be constructed as acts of faith, either by associations of citizens or wealthy individuals. The uniqueness of this, among other comparable symbolic power-systems (e.g.

Figure of Shiva with his bull, 9th century, stone icon on the Durga temple at Aihole

(Pps 56–57) Bracket images of fertility godlings, *c.* AD 500, carved on dynastic cave 4 at Badami

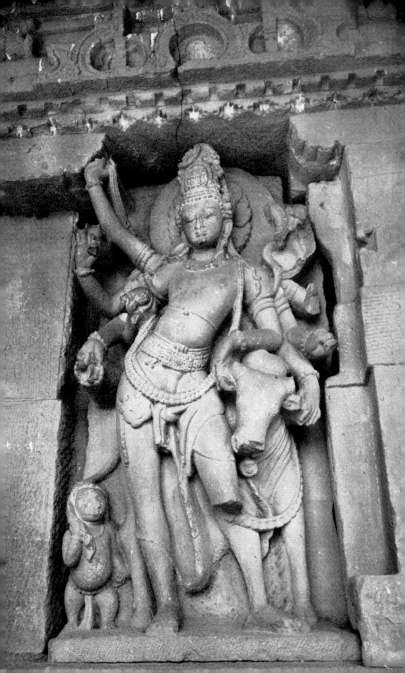

Early temples, including the Huchimalligudi, 6th century AD, stone, at Aihole

Egypt, Sumeria) is that it always preserved, at its roots, an invitation to each individual to achieve a status beyond the machine, an intuition invalidating his temporary and local limitations. If he learned how to 'read' it, the symbolism of the temple could point the way to his personal salvation.

Hindu temples always have two basic elements: first a cell, in which the central image stands—often a *lingam* or phallic emblem in Shaivite temples; and second a portico. The earliest temples follow closely this simple pattern, and so do less elaborate modern temples. But complications have been added to the pattern at different times in different parts of India. The earliest surviving temple of what became the basic Hindu type is actually Buddhist —a little shrine on Sanchi hill, built about AD 400. It is no more than a bare rectangular cell with a porch. The additions to and variations on this nuclear theme constitute the history of Hindu temple architecture. But one special characteristic of Hindu building is of particular importance: a temple is conceived fundamentally as a mass of rock, either living or piled up as masonry by man, which is then carved with the chisel both inside and outside into its final shape. The temple tower incorporates an image of the cosmic mountain Meru, which provides the earths

and heavens with their substance. So the internal spaces of Hindu temples are usually very small compared with the mass, and figurative sculpture is a major feature of the whole conception. The building is thus never an engineered structure, like Western cathedrals or Islamic pavilions; instead it usually either is, or 'aspires to the condition of' a monolith, metaphysically defining earth on which it stands.

In the southern Deccan the earliest recorded group of well over a hundred Hindu temples survives at the Chalukya capitals Aihole and Badami. A few have been selected for preservation. They show a variety of experimental types, only a few of which, with their towers, became canonical. In the Durga temple at Aihole the

Malegitti Shivalaya temple, 6th century AD, stone, at Badami

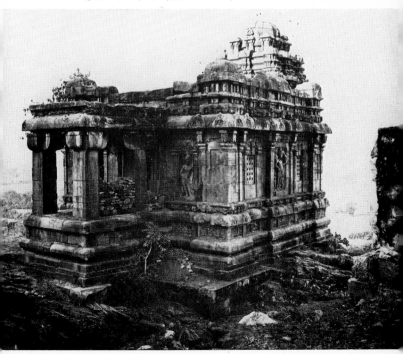

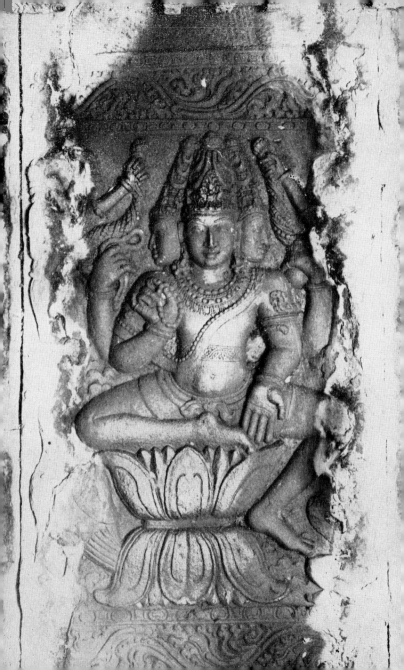

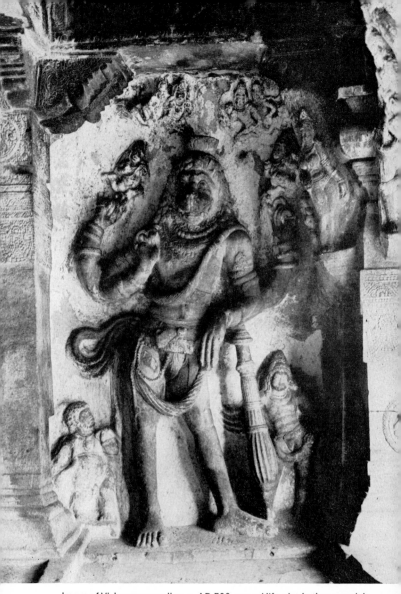

Image of Vishnu as man-lion, c. AD 500, carved life-size in the verandah to dynastic cave 3 at Badami

◀ Ceiling panel carved with the image of Brahma, 6th century AD, stone, in the Kontgudi temple at Aihole

Panel of foliate ornament, 6th century
AD, stone, from the temple of Shiva
at Bhumara

cell was contained in a hall with apsidal ambulatory, the whole enclosed in a verandah with celestial figures carved on the pillars. The 'Ladh Khan' had its cell set in the back wall of a square hall with double inner columniation and a portico, all covered with a slab roof. Of the types represented at Badami, perhaps the most significant was the first stage of what became the standard south Indian type, with a simple pyramidal tower.

An immense number of Hindu temples has been produced in India; they cover the whole countryside. Some are in great temple-cities which are still active; many are on the sites of cities and towns so long abandoned that they have been overgrown with jungle scrub. Others are in old cities now degraded to humble villages. They represent almost two millennia of continuous, often frenzied, building activity. Their sculptures illustrate the gods, the heavens with their celestial courtiers; foliate ornament and a complex counterpoint of mouldings and profiles burst out from the surface of the building as if it were filled with divine sap. The predominating flavour is of lush, sensual eroticism, with smoothly expansive surfaces, many of which were once painted in brilliant colours. Indian aesthetic theory (systematized by Kashmiri scholars by AD 1000) recognizes that aesthetic response is one of the legitimate kinds of religious realization, and that of all the possible modes of aesthetic response the erotic is the most effective. At the same time, the art which has appealed most directly to an Indian public is dancing with music. Thus most sculptures on Indian temples (even the horrific) exhibit their erotically flavoured figures in the elegant postures of the Indian dance, accompanied by musicians.

At all times and places there have existed side by side both modest shrines on the basic, simple pattern (crowning spire and portico), and temples of great size and relative complexity. They have followed the variety of local types described below; and most of the local styles reached their apogee between about AD 950 and 1230. In the south the high period lasted a few centuries longer. We can draw a broad distinction between northern and southern types, with the dividing line running near the twentieth parallel of latitude; though there are a few notable exceptions.

Temples

SOUTH INDIAN TEMPLES

In the south one of the earlier Chalukya patterns was developed for the shrines of the Pallava dynasty, who probably imported the worship of Shiva from the north. They were conceived as stone-cut palaces whose straight-sided pyramidal spires and roofs were ornamented with tiers of blind pavilions. A square main cell, hall and portico were aligned, with a pavilion for the image of Shiva's bull, Nandi, at Shiva shrines. The whole group was first of all (e.g. at Kanchi and Mamallapuram *c.* AD 700) tightly contained by a wall with cells around the interior, the passage resembling a roofless ambulatory. The walls have niches enclosed by pilasters. Also at Mamallapuram are the famous Seven Pagodas (*c.* AD 700) —small monolithic sculptures of structural temples carved out of seaside boulders—and two huge rock-face carvings with many

Rock carving, representing Arjuna's penance, late 7th century AD, Pallava, at Mamallapuram

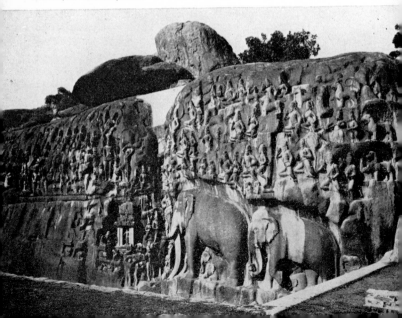

figures of gods, men and animals, which may represent the Shaiva myth of the 'Descent of the Ganges from heaven'. Some of the beautiful interior columns of these temples have lion caryatids in the lower part, their capitals and cushions being faceted to suggest up- and down-turned petals. The sculptural ornament is far less opulent than on most Hindu buildings, with no foliage and only few figures populating the niches. The sculptural style itself is cool and restrained, giving an impression of classical repose.

During the next two centuries this type of temple remained in use in the various cities of the Tamil south-eastern plains. And since this was the period of Tamil commercial expansion overseas, such temples provided the pattern for buildings in Ceylon, Cambodia, Vietnam and Java. Many small rock shrines were cut on a related style. Under the Cola dynasty the Pallava temple pattern was expanded to colossal size; the pyramidal tiers were multiplied; the sculptures, though still relatively static, also became

Cave-shrine, with guardians and lion-caryatids, 8th century AD, one of a group of Eastern Chalukya memorial shrines at Bhairava Konda

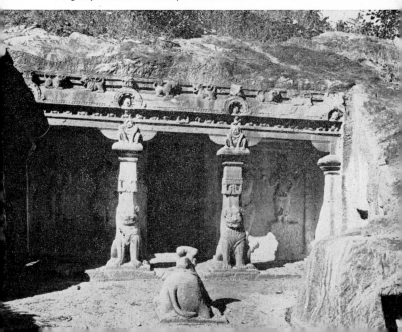

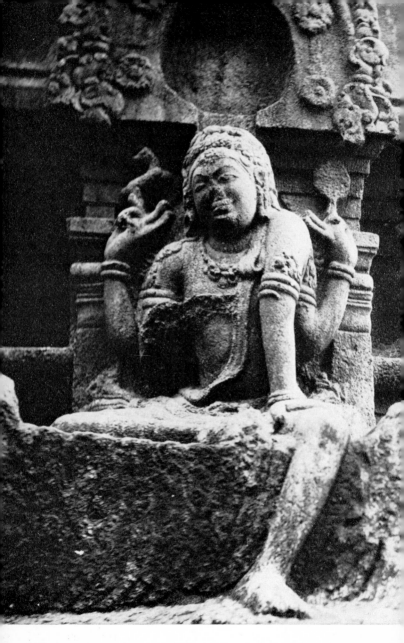

colossal; and around the main shrine-hall an ambulatory was often painted throughout, including dance-scenes. In the great Brihadishvarasvamin temple at Tanjore (*c.* AD 1000) there still survive a few opulent and sensual paintings of female dancers and of the life of Shiva. These were the temples which maintained troupes of live dancers, the Devadasis or Bayaderes, among whom the ancient traditions of the Indian Bharat Natyam dance have been preserved. Similar troupes may also have been the pattern for the court dance-troupes set up all over South-east Asia who performed their own versions of Indian classical dance.

Thereafter in the Tamil plains architecture developed mainly in the successively larger enclosures added to already existing temples by successive kings. While the original old shrine may be a modest structure, the gateway towers (*gopurams*) given to the enclosures developed into vaster and vaster straight-sided pyramids, topped, to save weight, by tiers of brick and plaster. These became the field for a display of coarse figures representing the whole of Hindu iconography; they have been continually reworked and garishly painted. In addition the courts of the earlier enclosures of important temples were often roofed and turned into huge aisled corridors with complex columns made up of groups of figures or animals (e.g. Madura and Trichinopoly, *c.* 1600–50). Superb individual works of architecture, such as tanks and pavilions, were added by rich private patrons within the outer courts. A tradition of wall-painting, marked by hard, heavy colour, ponderous curves and repetitive decoration, has been associated with some of the southern temples.

In the western Deccan, a basically Pallava architectural conception was adopted about AD 750. In the vast monolithic rock-cut temple of Kailashanatha at Ellora (*c.* 900) the pattern becomes far more 'baroque'. The Kailashanatha is the most impressive of a series of thirty-four caves at Ellora (Hindu, Buddhist and Jain) the chief beauty of which is their massively-conceived sculpture. Much of it is colossal or life-size, and there is a wealth of iconographic detail. The Kailashanatha stands in the centre of the

Figure of Shiva Dakshinamurti, 8th century AD, cut on a rock shrine at Vettuvankoyil, Tinnevelli

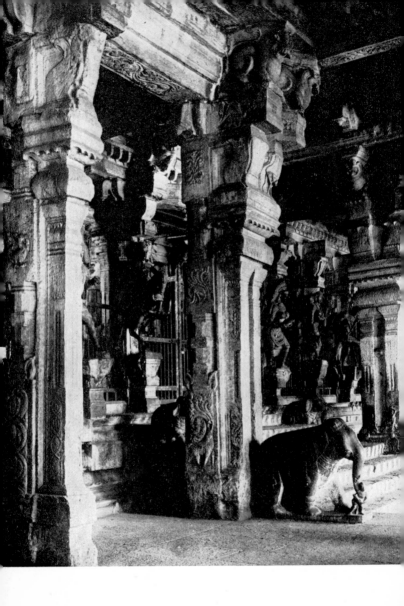

Interior of Minakshi temple

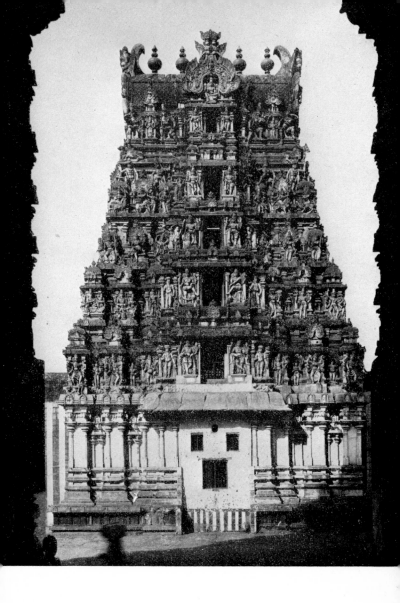

Gopuram of Minakshi temple, *c.* 1600, at Madura

quarry which was excavated around it, with cave-cells in the outer walls so as to echo the pattern of the Pallava courtyard-with-cells. The sculpture of this main temple exhibits a dynamic vehemence; deep-relief figures of deities in violently twisted postures seem almost to burst from their frames. There are also fragments of wall painting at Ellora, and plenty of evidence that part at least of the huge sculptural scheme was once plastered and painted.

Kailashanatha temple, c. AD 900, colossal monolithic shrine, at Ellora

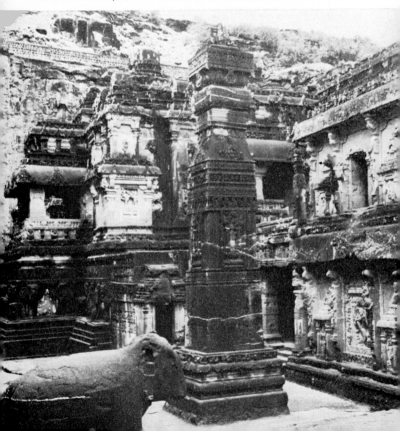

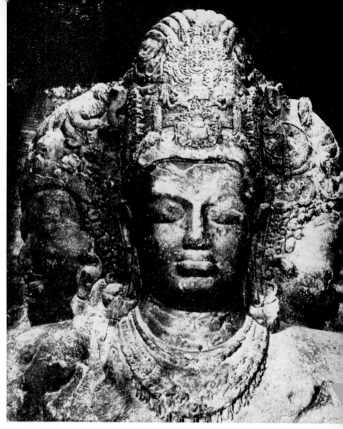

The Trimurti a colossal bust icon, *c.* AD 800, in the cave temple on Elephanta Island, Bombay

Not far away at Aurangabad another group of contemporary caves contains fine, massively sensuous, Buddhist figure-sculpture including goddesses. Two quite exceptional groups here are the female dancer with musicians (cave 7), and the kneeling devotees (cave 3) who are cut almost in the full-round.

The cave-temple on Elephanta island off Bombay is famous for its colossal Shiva sculptures. A central three-faced bust icon, represents the peaceful, the female-progenitive and the destructive aspects of the god; it is flanked by reliefs illustrating incidents from his legend. These, with other roughly contemporary rock-cut

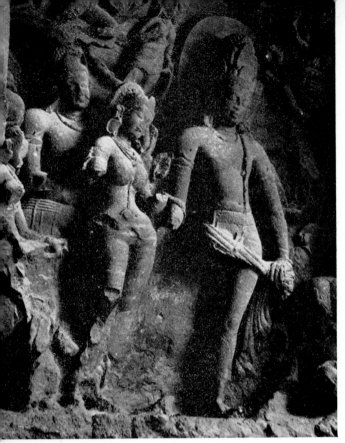

The marriage of Shiva and Parvati, *c.* AD 800, colossal relief in the cave temple on Elephanta Island

View of brackets under the eaves of the main shrine, 12th century, stone, ▶ at Palampet

work, are legitimate descendants of earlier Buddhist traditions of rock-sculpture initiated in the western Deccan—carried over the centuries, no doubt, in lost work.

In the northern and western Deccan the situation was complicated by the intrusion of Islam and Islamic types of art about 1300; but before then a tradition of temple building related to the Rajasthan version of the northern type (see below) had arrived (e.g. Ambarnath, Bombay, in the eleventh century; Jhogda,

Mankesvara, Nasik in the twelfth century). At Gadag (twelfth century), for instance, a growing interior complexity produced fantastic pillars ranked with elaborate 'lathe-turned' mouldings. The highly mannered figure-sculpture at Palampet (twelfth century) includes preternaturally slender, almost insect-like female dancers. And in the same century, in the Hoyshala state of Mysore, the Rajasthan type underwent a strange, tropical transformation. Star-shaped ground plans were adopted, and linked rows of shrines on a single plinth (Somnathpur, Belur), while the whole exterior of the shrine, including its somewhat puddingy figures in very high relief, was carved with dense foliage ornament, deeply undercut to stand out from a ground of shadow.

Finally there is the art of Vijaynagar, a state in the Deccan which stood out against Islamic neighbours until 1565, when almost all its ornate stone buildings were systematically destroyed. A few outlying temples survive, for instance at Lepakshi and Anegundi, and two contain quite elaborate painted schemes of the fifteenth century; while at Tiruparutikundram some Jain fourteenth-century painted ceiling-panels survive. None are outstanding works of art, being somewhat limited and over-schematic.

Carved lintel, with a fantastic monster, 12th century, from a Hoyshala temple in Mysore

Image of Vishnu as man-lion fighting the demon Hiranyakashipu, 15th century, black stone, colossal, from Ramnad

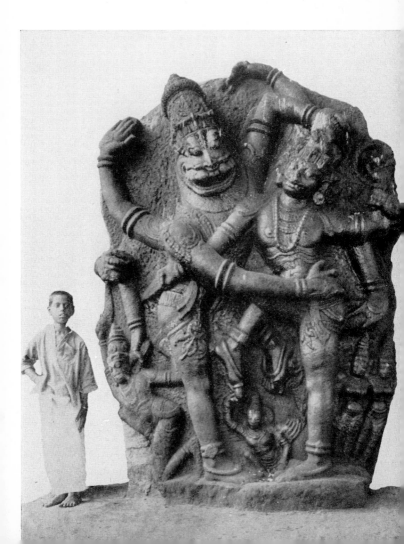

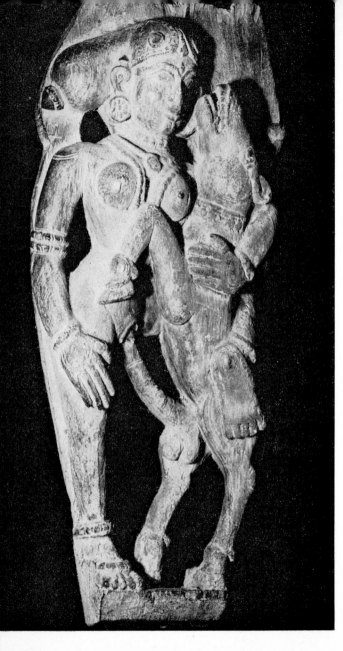

NORTH INDIAN TEMPLES

The typical northern temple is conceived as a representation in stone of the cosmos centred on the mountain Meru, which rises through the different realms of existence. The plinth represents earth under its ideal aspect, with many transverse mouldings, and sculptures from heroic legend, representing scenes which took place on earth. Stairs lead to the main, raised level, to enter which is to enter heaven. The door frames are decorated with foliate ornament, little relief panels of amorous couples, and the purifying goddesses of the rivers Ganga (Ganges) and Yamuna (Jumna). The interior, ambulatory and verandahs, may be finely decorated

◀ Erotic bracket figure from a temple-car, 16th century, wood, *c*. 20 in. high, from Madras

Sculptured panel illustrating a legend of Vishnu, 7th century, stone, at Deogarh

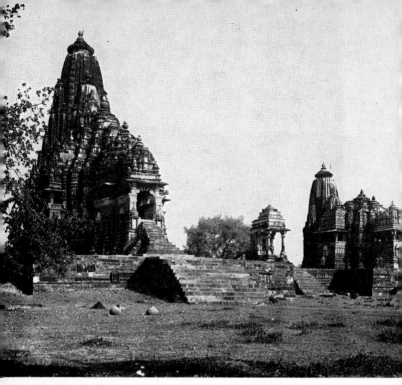

Kandarya Mahadeva temple, *c.* AD 1000, stone, at Khajuraho

with ornamental carving—for these are the halls of heaven. The outside of this level bears bands of sculptured figures which represent the inhabitants of the heavens—the gods and immortals. Among them are celestial musicians and the divinely beautiful, eternally passionate Apsarases, who reward with superhuman sexual pleasure heroes and saints for the virtue of their earthly lives. Above the shrine towers a pyramidal spire with a gently convex contour, buttressed by ranges of lesser spires, crowned with gadrooned fruit-like discs; its shape suggests that beyond the heavens there is a region of unrepresentable truth.

This type of temple varied at different places and times. At Deogarh (*c.* AD 700), modest in scale, it stood on a square plinth with four access stairways and four pillared porticoes dominating the four axial directions of cosmic space, but a single doorway. The other porticoes sheltered relief sculptures of Hindu cosmo-

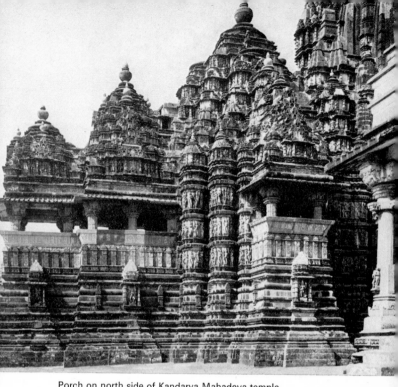

Porch on north side of Kandarya Mahadeva temple

gonic deities. At Bhitargaon, near Kaunpur, an early example of
a brick pyramidal temple-tower stands on a high plinth whose
faces are tiered with flat pilasters and window arcades; a stairway
rises directly into the shrine itself. Buddhist shrine-towers
followed this pattern, as did many temples in South-east Asia,
while the Buddhist shrine at Somapura in Bengal, founded by
Devapala, was a vast elaboration in brick of the Deogarh cross
plan.

In central India a series of dynasties sponsored the building of
many temples. The most famous group is that at Khajuraho
constructed between about 950 and 1050 under the Chandella
dynasty. Twenty-five substantial temples survive out of an
original total of over eighty, all built around a large lake and
forming a huge religious city. Most follow the typical pattern of
the temple-mountain, with an ambulatory under the spire and two

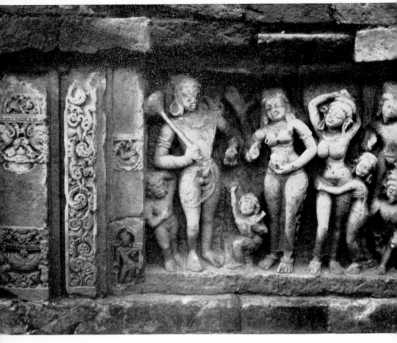

Relief representing a Shiva legend, 6th century AD, stone, from Paharpur

Door frame of a ruined temple, *c.* 1100, stone, at Khajuraho ▶

porticoes aligned with the cell. One temple is laid out as a structural cosmic diagram around a court; and some, notably the Vishvanatha, have interiors covered by shallow domed ceilings elaborately fretted with ornament and figures. Perhaps the most impressive is the towering Kandarya Mahadeva shrine, with its famous erotic figure-sculpture, which must rank as one of the peaks of Hindu artistic invention.

In Rajasthan some temples at Osia, another abandoned royal-religious city, display a fragmentary history of post-Gupta architecture, from the eighth to the tenth centuries. Their modest

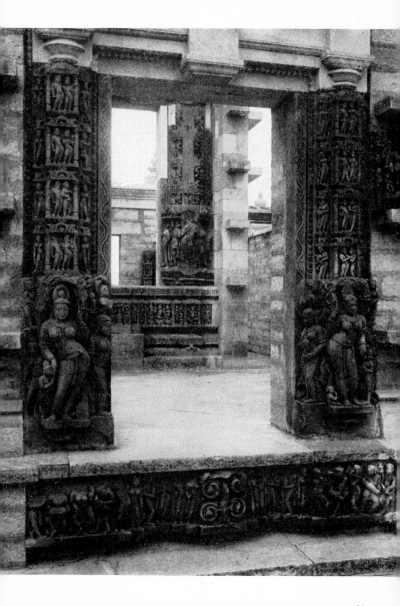

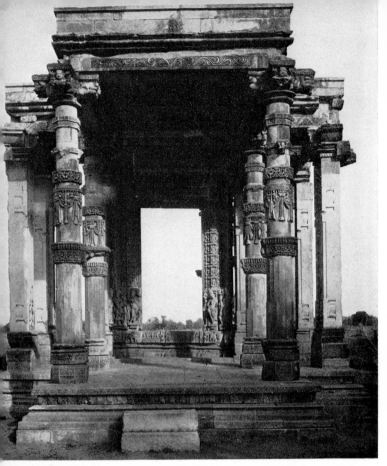

Portico of the Gantai temple, *c*. AD 1000, stone, at Khajuraho

towered cells are approached by pillared halls, open on plinths.
The main feature of other eleventh-century Rajasthan temples at
Kiradu in Udaipur and in Gwalior State, with the squat towers
ornamented in regular vertical and horizontal bands, is the open
hall with a complex pillar-system, elaborately profiled and carved,
integrated into the cell-portico pattern. In all western India the
open pillared hall, used as a dance pavilion, aligned with but
separate from the cell and portico, became the outstanding
element of the shrine. That of the Sun temple at Modhera

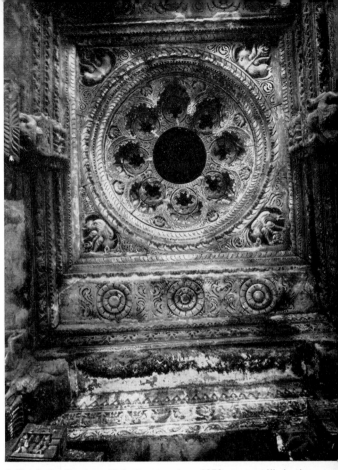

Ceiling in the Kandarya Mahadeva temple, *c*. 1050, stone, at Khajuraho

(eleventh century), beside its beautifully stepped tank, is the most famous; but there are many others, notably in Kathiawar.

The medieval Jain shrines, elaborately carved in white marble, on the famous sacred hill of Mount Abu in Rajasthan have been continuously restored by the wealthy Jain community, so very few are entirely original. The Vimala Saha is outstanding. Other Jain temple-cities at Palitana and Girnar in Kathiawar contain early medieval tower-shrines and halls. One characteristic type is a fortress-like enclosure containing pavilions grouped around

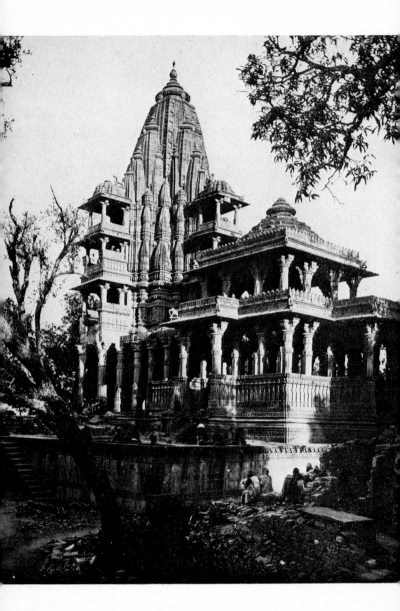

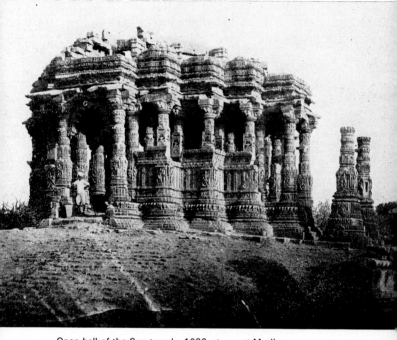

Open hall of the Sun temple, 1026, stone, at Modhera

◀ Temple, c. 1100, stone, at Kiradu

a free-standing tower shrine. In Gwalior the eleventh-century
larger Sas Bahu temple uses a special theme. Its porticoes are set
into pillared porches which rise in diminishing tiers. The Govind
Dev temple at Brindaban (c. 1590) uses a similar theme, enclosing
the whole cell in a double-storeyed verandah on a cross plan, with
strong emphasis on horizontal elements. In Orissa, however,
which never succumbed to Islam, the vast temple cities of
Bhuvaneshvara and Puri contain within themselves a whole history
of temple evolution from about AD 750 to 1400. Perhaps the
greatest temple among them, the temple of Jagannath at Puri (c.
AD 1000), has three halls aligned with the chief shrine, all roofed

Panel from a toilet box, *c.* 1640, ivory, from Bengal

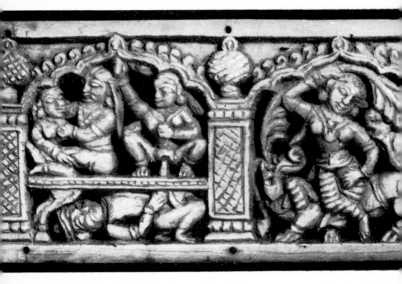

Gateway arch of temple of Mukteshvara

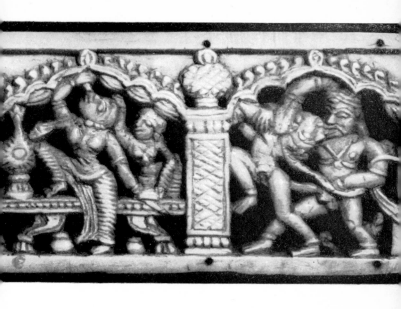

Temple of Mukteshvara, mid 9th century AD, stone, Bhuvaneshvara

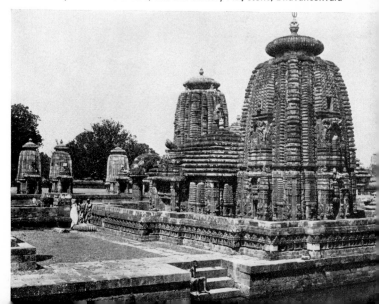

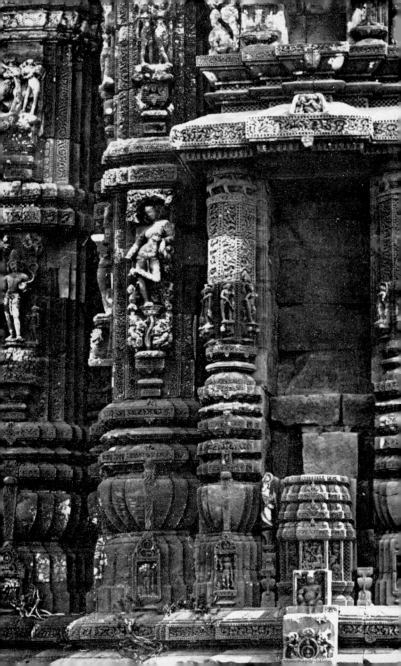

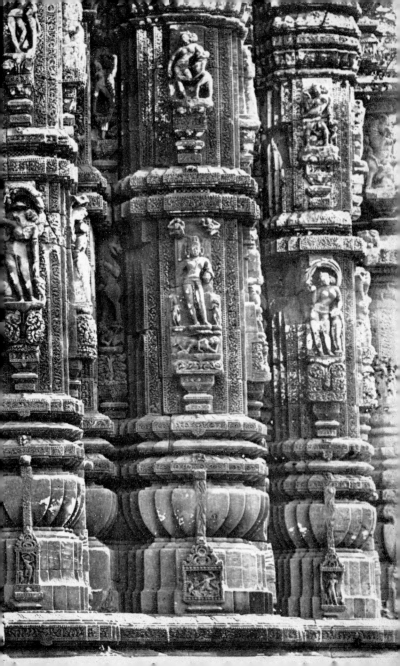

with ornate pyramids. And the huge, incomplete Black Pagoda (thirteenth century), the temple of the Sun on the Orissan coast at Konarak, is world-renowned as a temple of Love; for its sculptures illustrate innumerable variations of sexual activity. The terraces carry colossal free-standing stone figures of female musicians. It is conceived as a sun-chariot, with ornate stone wheels, the draught animals represented by colossal carved boulders.

In addition to the main-line traditions, characteristic styles developed in self-contained outlying regions. Such were the Kashmir style, with its chaste, tall-gabled stone versions of the Deogarh plan (Avantipur); other Himalayan hill-styles, like that of Kulu were executed in stone and wood with tiered gable roofs and their shrines often contain old bronze images. A similar

Temple of Shatrunjaya Keshavji Nayaka, *c.* 1150 and later, stone, at Palitana

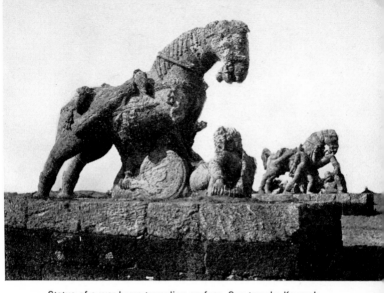

Statue of a war horse trampling on foes, Sun temple, Konarak

Wall sculptures in Sun temple, early 13th century, stone, at Konarak

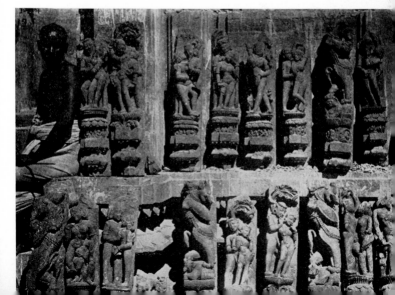

type is still built in different parts of the far south of India, notably in Malabar, Travancore and southern Kanara. Many of these structures are temples surrounded by elaborate wooden porticoes under the eaves of gabled roofs, the central shrine itself being surmounted by one or two gabled tiers like a small pagoda. In Bengal during the later Middle Ages brick temples were built with strange drooping-curved roofs, their walls faced with panels of terracotta sculpture. All these have detailed histories of their own, and small-scale art can be associated with them.

The sculpture of northern temples is an integral part of their fabric; and although the styles are distinct, allowing of quite accurate dating and location, they share a deep community of purpose and method. The figures of the principal Hindu deities which appear either as icons in the chief shrine or in the heaven-bands on the external faces of the towers and pavilions illustrate the gods as paragons of opulent beauty. The inflexion of each individual unit of form adds a delightful metaphor. The women, the texts say, have bosoms rounded 'like golden cups', they twine 'like creepers' around their lovers. The faces of men and women are broad 'like the full moon'; their noses have the high delicately arched bridge 'like a parrot's bill' recognized as typically Aryan, and hence high caste; their lips are full and curved 'like the petals of the sesamum flower'; their brows are curved 'like a bow'; and their eyes are long, 'like a fish' or a 'willow leaf'. The sculptors carved bodies according to well-understood proportional schemes; these were preserved and described in illustrated manuals, which contained the accumulated method of the guilds, technical and iconographical. The sculptures had to be correct as well as beautiful.

Indian deities are often given many arms, heads and legs. Gods, of course, are not human; and sculptures of the gods are sculptures not of people but images of ideas. Each hand may carry some emblem or make a specific gesture, each head wear a different expression, referring to powers and metaphysical characteristics ascribed to the god, or to some legend. Shiva, for

Image of the goddess, *c.* AD 600, bronze, in a temple at Chhatrarhi, actively in worship

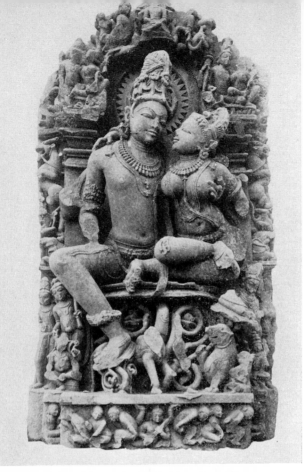

Icon of Shiva and Gauri, *c.* AD 1000, stone, from Khajuraho

example, may have four arms, one holding a trident, one a snake, two others making gestures, and have perhaps three faces, the centre one showing his ultimate, impassively peaceful aspect, that on the left his female creative counterpart, that on the right his ferocious aspect as universal destroyer.

Another characteristic of medieval Indian sculpture is the way in which it treats drapery. The artist concentrates on shaping the body. Clothes follow its volumes, save where they hang free ; and

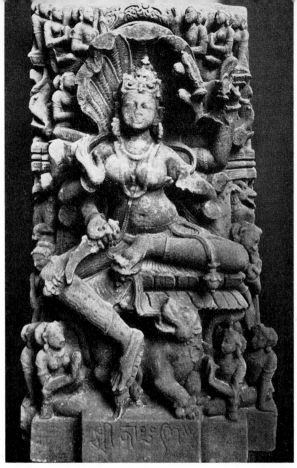

Icon of a Serpent deity, *c.* AD 1000, stone, from Sutna, central India.
Indian Museum, Calcutta

there they are shown as concave. The only exceptions are in some
post-sixteenth-century Rajput and Bengali sculpture.

Technique is dominated by pure convexity; all bodies must, like
a pot, demonstrate how they 'contain' space. Where concavities
might be expected to appear on a human body, for example at
the inner corner of the eye, they are rendered as hollows where
convexities meet. Surfaces are developed as functions in space
of deep, sinuous curves, which produce a smooth unity over the

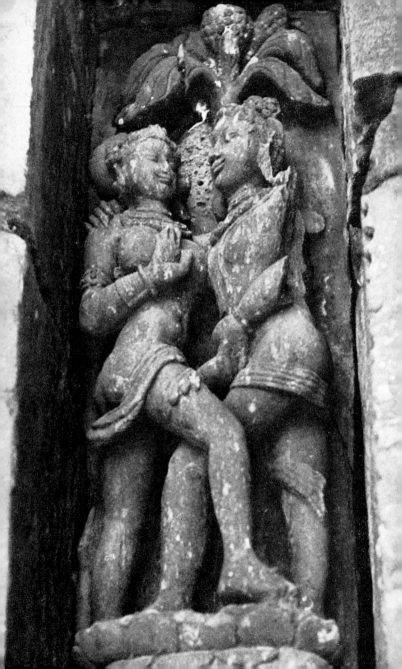

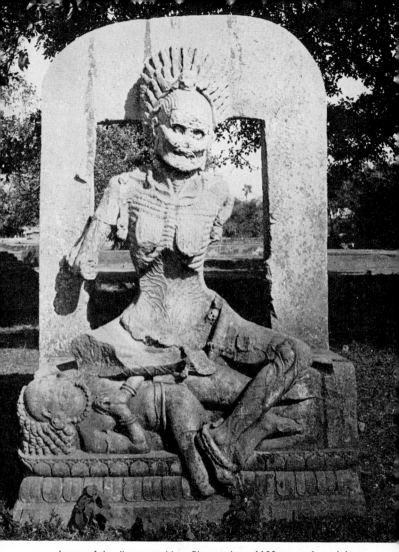

Image of the disease goddess Chamunda, *c.* 1100, stone, from Jajpur, Orissa

◄ Pair of celestial lovers, on the heaven-bands of the Rajarani temple, 11th century, stone, Bhuvaneshvara, Orissa

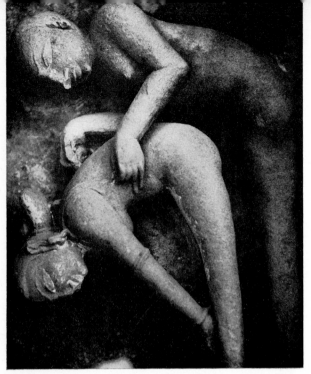

Ritual intercourse, *c.* AD 1000, stone, on the plinth of the Lakshmana temple at Khajuraho

Serpent deity, *c.* AD 1000, stone, from Khiching. *Indian Museum, Calcutta* ▶

surface while embracing the volumes within their slow undulations. The units of form correspond with the broad, named members of the body, taking no account of minutiae of anatomy. Forearm, upper arm, hand, cheek, are treated as single rounded volumes each running into its neighbour volumes with the minimum of complication. The elaborate ornaments are raised on the rounded volumes, and the separate beads of necklaces and girdles contributed a rhythmic element circling in the third dimension. Concavities appear as leading sculptural elements only in the bodies of horrific deities of death and disease.

The differences between local styles of sculpture in northern India can be assessed by variations in the characteristic shapes

corresponding with various parts of the body, by the ways in which these are joined to each other and by variations of proportion. For example, a group of the principal styles at Khajuraho give to their figures long, column-like legs, and very sinuous bodies with particularly deep clefts in the hollowed backs of women. On western, and western central Indian temples, the curved volumes of the units of mass may be deeply bowed, their junctions being narrow and the ornaments deeply cut. In Orissa the volumes are only lightly inflected and run into each other smoothly and directly; the splendid sculptures from the small temples of Khiching in Mayurbhanj state, Orissa, achieve a smooth and gentle surface-unity perhaps more successfully than anywhere else in India.

South Indian bronzes

From Pallava times there has existed in the Tamil regions of south India, including Tamil Ceylon, a splendid art of bronze casting. It was used on a large scale chiefly for sacred processional images, which identified a king with his god or a queen with a goddess. These are virtually the only Indian sculptures in the full-round, to be seen from all sides. The finest, those of the early Colas (*c.* AD 1000), are superbly elegant works of art, delicately and sensuously modelled. Many are still in worship in southern temples, but there are many smaller examples in museums in India and the West; perhaps the best known represent Shiva as 'lord of the dance'. The slender, undulating and rounded elegance of these works distinguishes them sharply from most of the rest of Indian sculpture. Tanjore seems to have been the centre for their manufacture during their greatest period. The art was later encouraged at the other great temple-cities in the south, Madura having a flourishing school during the sixteenth century. Such things have been continuously made into recent times, their styles parallel with the stone-cut styles, becoming gradually more ornate

Processional image of a goddess, *c.* 1020, Cola, bronze, from Madras

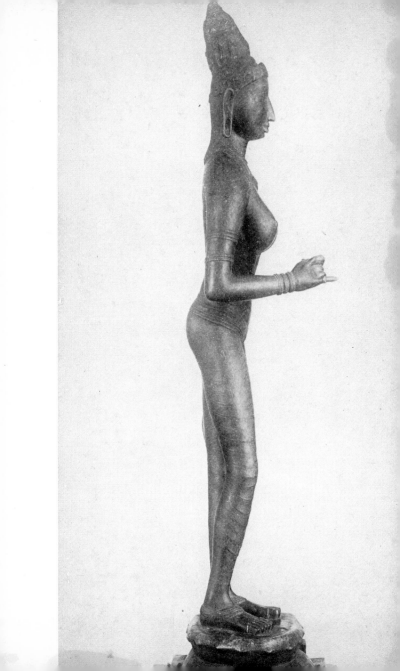

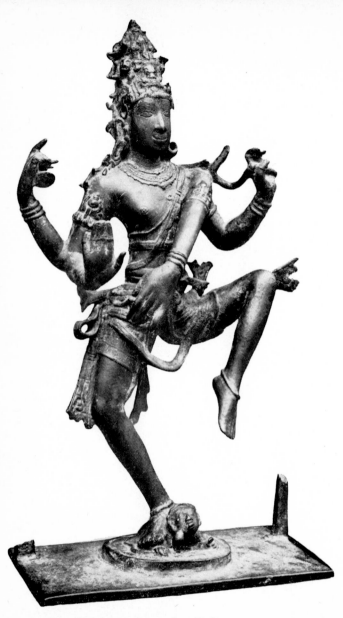

Dancing Shiva, 12th century, bronze, from Tanjore

and less imbued with the directly sensuous feeling of the older works as the centuries progressed. Many domestic icons were also made on a smaller scale. In recent decades numerous forgeries have also been produced.

Early miniature painting

There were four major traditions of medieval manuscript-illumination, two of which are still active. The first, now defunct, was carried on in western India and Rajasthan. No one knows how old its earliest examples on palm leaf are; after *c.* 1400 it was carried out increasingly often on paper, and superseded some time after 1550 by post-Mogul styles. Most such work survives in the pages

Manuscript illumination, *c.* 1450, gouache on paper, western India. *Gulbenkian Museum, Durham*

Manuscript illumination of the Mahabharata war, 16th century, gouache on paper, from south India. *Gulbenkian Museum, Durham*

Manuscript illumination of the God of Love shooting a flower arrow at a girl, 17th century, stylus impression on palm-leaf, from Orissa. *Gulbenkian Museum, Durham*

The goddess of wisdom, Sarasvati, 19th century, watercolour on paper, 15 in. high, from Kalighat, Calcutta. *Victoria and Albert Museum. London* ▶

of Jain religious texts, mainly dealing with the lives of saints, preserved in the libraries of Jain temple-cities and wealthy Jain families. This art was also used in western Rajasthan for Hindu manuscripts, only a few of which have been preserved. The stereotyped figures with their painted features are drawn without modelling in springing, wiry black outline, arranged conceptually in the format. Colours are limited to dense primaries, chiefly red and blue, with gold or silver added.

The second style is contained in palm-leaf manuscripts of Orissa, still made. The design is impressed on the leaf with a stylus, colour is rubbed into the impression, and sometimes tints are added to the areas, or to features like lips and eyes. The drawings, which usually illustrate Hindu classics, some of them erotic, are composed of lines alone—deeply looped curves and curlicues. The third style is that of Bengal, which today survives as a village art in a number of different traditions. It sprang from a tradition represented by the illuminated Pala palm-leaf manuscripts. But after Buddhism vanished from Bengal in the

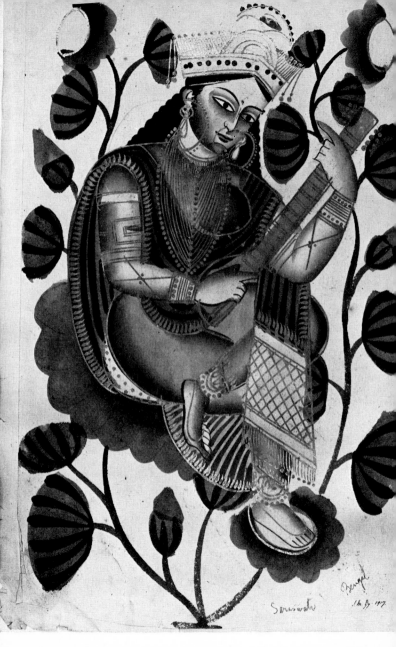

Saraswati Bengal

thirteenth century it was adapted to illustrate the pages and wooden casing-boards of the texts of devotional Hinduism. During the last two centuries this style, with its wiry, often in-consequent line and bright colours, has been used for illustrating popular tales, for the picture-rolls used by itinerant storytellers to give life to their recitals, and for that kind of diagram-art which summarizes in visual form the doctrines of metaphysical Tantra. In a version developed at the Kalighat temple in Calcutta in the nineteenth century it was even used to illustrate topical events. Its manner became boldly swift and casual, using European watercolours completed by strong black outlines, and running coloured bands of modelling tone along the inside of the con-tours. The twentieth-century painter Jamini Roy has revived and refurbished the conventions of the village style of Bengal for use by modern pseudo-naif artists.

The fourth medieval manuscript tradition is that of south India, which is scarcely known at all in the West. Like the art of bronze casting, it was probably at its best in Tanjore; but it was also practised in many other southern cities. The more recent styles by which it is known are marked by heavy, emphatic loops tending towards the arc of a circle. Figures have solid, pot-like arms and legs; colours are intense and simplified; and the composition of scenes illustrating manuscripts of the heroic epics lacks any suggestion of pictorial space. It is descended from early Cola work, which shared something of the refinement of the bronzes. Its latest productions are more often seen, in the form of sets of Hindu deities, types or festivals, painted on mica or paper for European patrons, principally at Tanjore.

Popular story-scroll, 19th century, watercolour on paper, 12 in. wide, from Bengal

Islamic art

Islam entered India in the wake of military adventurers in search of loot and personal prestige. In 1206 the first Muslim sultanate was established at Delhi. The Muslim architecture with its magnificent carved ornament created there under the rule of successive dynasties testifies to Indian skill and adaptability. For then, as earlier, Muslim invaders employed native talent to execute their artistic projects.

Islamic art does not have a true religious iconography. Although there is no prohibition in the Koran against the representation of living creatures, by the ninth century an opposition to it had

Sher Shah's mosque, *c.* 1530, stone, at Delhi

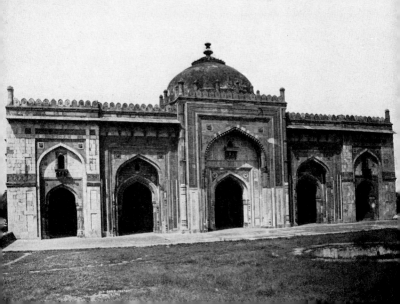

grown up which became enshrined in tradition. The only purely religious art produced in Islamic countries, other than manuscripts of the Koran, is based upon the mosque. This is a large enclosure, orientated towards Mecca, in which the faithful gather to pray. The Mecca-facing end may have a roof supported by a few bays of arches, and a cloister may run round the interior. The focal point is the Mihrab, a niche in the wall facing Mecca, usually framed in ornament. But there may be ornament on many other parts of the building, especially around the windows, in arcades and domes, and along the architraves. Mosques were often attached to the palaces of government officers, and to important tombs.

All the other arts of Islam were devoted on the face of it to personal luxury and self-enhancement, flattering the senses, exalting the personality of the owner, rather than giving direct spiritual enlightenment. Palaces and tombs demonstrated the patron's grandeur, public buildings his munificence. Domestic and garden architecture refreshed his senses, while lesser sumptuary arts, such as metalwork, pottery, swords and textiles demonstrated his social status, on the assumption that to indulge in luxury is the normal social goal. These objects may be inscribed with apt quotations, often from the Koran. But art reflects inevitably the artist's visual-ontological intuitions, whatever its superficial purposes may seem to be; so even the most secular Muslim art expresses through its conceptual language of form a sense of structure parallel to that expressed in the most exalted religious literature. Beauty, to the Muslim, is reflected in an order impersonal as the constellations.

Islamic decoration is based on images and similes used repeatedly for over a millennium in conversation and in literary art to denote both earthly beauty and its heavenly analogues. Decorative motifs such as the lamp fed by the oil of divinity, the tree of life, the star, the rose, tulip, iris, gazelle or moon-faced beauty, are heavily charged with associations from the Koran and major poetry. The structural sense implicit in arabesque ornament, based on the flat winding design which returns upon itself, is also that developed in literature and the whole Muslim–Arabic way of thinking and feeling. The luxury conveyed in such ornament

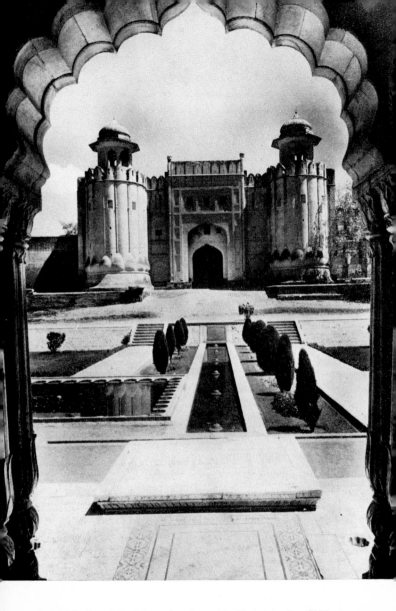

Gate of the Hazuri Bagh (a garden planned for Shah Jahan), *c.* 1630, at Lahore

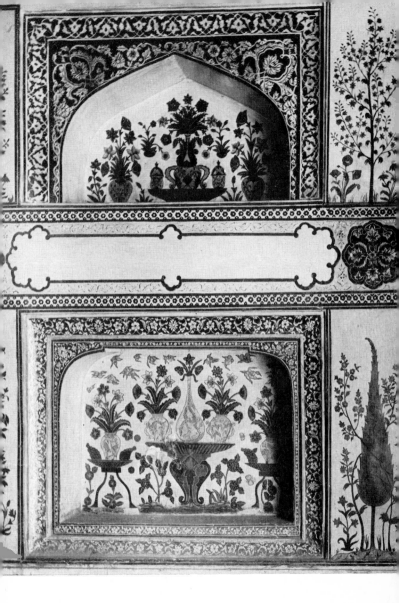

Painted decoration on the interior of Akbar's tomb, *c.* 1604, at Agra

Stone-cut inscription on the mosque of Zafar Khan Ghazi, dated 1298, Bengal

is in the refreshment and tranquillity it can instil. To the degree that it loses its sense of inherent subtle order it degenerates into vulgarity.

The decorative arts of Islam all rest upon the nuclear idea of perfectionist calligraphy. The Arabic script is the vehicle for the most sacred religious text, the Koran, the only channel of Truth, and it has always been regarded as the Muslim scribe's highest religious duty to make his handwriting the most perfect embodiment for the sacred word. In all Islamic countries the calligrapher's has been cultivated as the major art. His lettering incorporated as

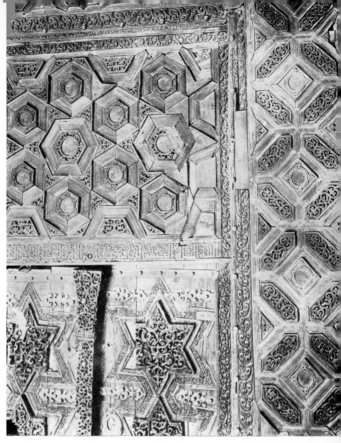

A corner of the Ghazni gate, *c.* 1600, wood, in fort at Agra

faithfully as possible one or other of the recognized perfect canons of script. The glory of God was reflected in its beauty and abstract geometrical perfection. Calligraphy ornamented all kinds of art, including architecture. Stone-cut, it was generally first hand-written by distinguished calligraphers. All the other decorative forms used in architecture, which do not have the accepted patterns of lettering as their basis, elaborate and combine a variety of geometrical forms, given in India a clothing of vegetable symbolism. For the diagrammatic designs of plane geometry, which make no pretence to embody the reality of created things,

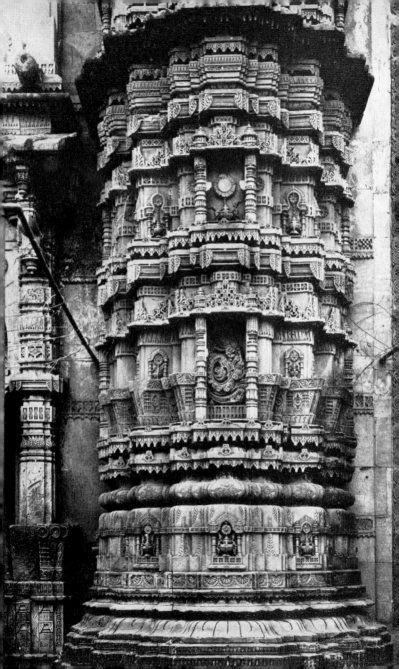

and do not 'cast a shadow', were held to approach more closely to the divine ideal than any forms taken from the created world. A similar kind of reasoning lies behind the development of three-dimensional schemes of proportion in Islamic architecture. The beauty of buildings combining a number of different geometrical formulae expresses in concrete form an image of glory by ideal patterns of abstract reason. Surfaces were emphasized to reflect the light—God's light—as fully as possible.

In representational arts, such as miniature painting, Islamic masters always based their work upon highly schooled brush-strokes executed without a tremor of the hand, while seeking a clear, enamel-like brilliance of colour. Perfect rhythmic surface was everywhere the aim, God's perfection dominating the natural.

The Muslims in India continued to use decorative designs from the older Islamic countries of the Middle East. But for the actual construction of mosques, tombs and palaces they depended upon the skill of Indian builders, and new styles evolved, embodying original interpretations of space in terms of punctuated surface. Older Hindu buildings were destroyed and their pillars and stonework were re-cut for the conquerors to construct buildings more in accordance with their own ideas. In fact there was an acute conflict of feeling between foreign Muslims and native Indians with respect to the forms of art; for the Indian concentra-tion upon massive protuberance and physical plasticity, as well as love of anthropomorphic volumes, seemed grossly offensive to Muslim eyes. As time went on the power of Islam expanded over the whole northern part of India down into the Deccan, and many independent Islamic sultanates were established. In the course of four centuries of violent and bitter warfare, Hindu culture in most of the north-western and northern regions of India suffered severely; nevertheless the Muslims came to accept and assimilate many of the native Indian elements of plastic design, especially in architectural detail.

Base of the minaret of the mosque of Miyan Khan Chisti, c. 1465, stone, at Ahmedabad

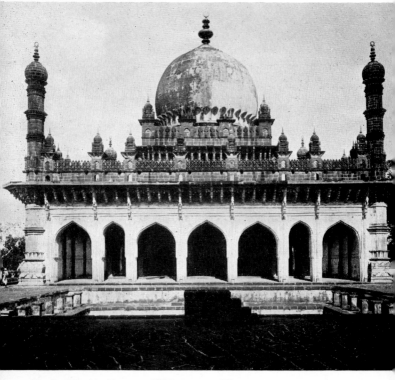

Tomb of Ibrahim Rauza, *c.* 1620, stone, at Bijapur

Early Islamic architecture

The chief monuments remaining from the early Muslim dynasties
are the tombs of the sultans and their families. Around Delhi there
are many stone structures, usually based upon the Seljuk tomb
plan of a rectangular chamber crowned by a dome, symbolic of
the conjunction of earth and heaven, with carved inscriptions.
The tomb of Sher Shah in Bengal takes this pattern to its extreme,
with the basic hall extended outwards on to a plinth as an arcaded
octagon, and small domed canopies standing at each corner of

its two terraces. In the Deccan, at Bijapur, a strange style of tomb architecture developed, with high onion domes raised on drums above tall cubical volumes, enormous bracketed eaves and an exotic form of ornament based on down-turned petals. Its Indian character is betrayed by its emphasis on the plastic mass of the members. Whereas in Persian architecture such features as arcaded niches generally represent punctuations in flat, decorated areas of wall, in Indian the architectural elements are separate and distinct from each other, clearly defined in space. Apart from certain tombs in Multan, and the Nil Gumbad at Delhi, it was not until the seventeenth century that it became customary in India to decorate entire continuous wall surfaces.

The earliest major Islamic buildings to survive in India are mosques. Qut'b-ad-Din's mosques at Ajmer and Delhi, together

Interior of the tomb of Ibrahim Rauza, at Bijapur

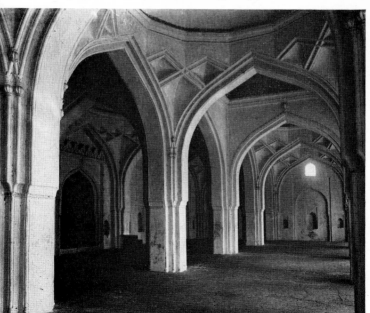

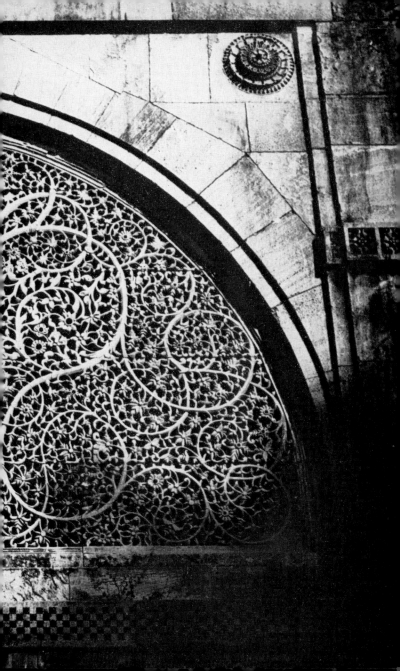

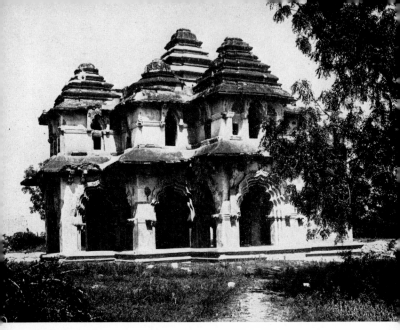

The Lotus Mahal, *c.* 1575, stone, at Hampi. A Muslim building erected in the old capital of the Vijaynagar empire

The Qut'b Minar, early 13th century, stone, at Delhi ▶

with the tapering gadrooned tower known as the Qut'b Minar at Delhi, which is actually the free-standing minaret to the mosque connected with the Ghaznavid funeral towers, were constructed from the local reddish stone by Indian craftsmen in the early thirteenth century. The straight-sided pointed arcades of five and seven arches which form the façade of their sanctuaries are constructed by the Indian corbelling technique. The main beauty of these buildings is in their bands of superb relief ornament and Kufic and Arabic script, which were cut from Persian originals. There are other mosques, for example at Jaunpur and Ahmedabad, which represent further stages of this cultural assimilation. Special features are the window lattices of pierced stonework in sumptuous floral and abstract designs, and plastic detailing based upon traditional Hindu stone-cut forms. There must have been other arts produced at the courts of these sultanates, but of them we know virtually nothing.

EARLY MUSLIM MINIATURE PAINTING

We do know, however, that during the fifteenth and sixteenth centuries manuscript painting from Persia was finding its way to the Muslim courts of the Indian sultans. Our earliest evidence for direct Islamic influence on native styles of painting comes from the Muslim state of Malwa. About 1500 an Indian painter working there modified his style under Persian influence, decorating a book of recipes, the *Nimat Namah*. He adopted Persian facial formulae, adding them to basic Indian layouts of small scenes. Most important, he adopted the Persian technique of colouring with a wide range of mixed and graded tints for the garments of his figures, creating fresh and varied colour-sequences in each picture. In the sixteenth century, at the Muslim courts of the Deccan (especially in Ahmadnagar, Bijapur and later in Golconda), a most interesting and important synthesis was made between native Hindu manuscript painting, much as it was practised in the neighbouring Hindu state of Vijaynagar, and imported Persian styles. Some of the sumptuous manuscripts deal with Hindu mystical learning, some are Islamic versions of Hindu poems dealing with music and love, some illustrate Muslim ideology in Hindu guise. Unfortunately no manuscripts earlier than the Mogul period are yet known ; but there can be no mistaking the fact that those which do exist, dating between 1565 and 1600, represent an independent tradition.

Many of the painted manuscripts look in general like works in a brightly-coloured, sixteenth-century Rajput style (see below) which have been re-thought in terms of fluent Islamic outline and more sophisticated but still hectic colour. The clear volumes of the enclosures natural to Hindu art are partly broken down, and Persian patterning spreads over the ground. But at the same time Hindu conventions remain in the figure types, in details of the features, in the treatment of clothes and in the careful division of the picture-space. After the turn of the century, however, Mogul influence was most powerful at the Deccan courts.

Mogul art

The Mogul dynasty produced the most famous works of Muslim architecture and art in India. This dynasty, like its predecessors, originally stemmed from an immigrant family of military adventurers. The second emperor, Humayun (d. 1556) spent a temporary exile at the brilliant court of Shah Tahmasp of Persia. When he returned he brought back artists, including miniature painters who had been pupils of the great Bihzad. Chief was Mir Sayyid Ali, who became the leader of the Atelier maintained by the Mogul dynasty. The third ruler, Akbar (d. 1695), made his reign one of the most artistically glorious in Muslim history. Near his first capital, Agra, he built a complete capital city for himself, Fathpur Sikri, which became a kind of forcing-house for the evolution of joint Muslim-Hindu architectural ideas. He established a great library and recruited from all parts of his empire painters, illuminators, craftsmen and musicians to add lustre to his court. Muslim artists worked for him along with many Hindu painters.

Akbar's buildings are constructed by pillar and canopy, with long projecting eaves and arches with multiple lobes and profiles. The tomb Akbar's mother built for his father, Humayun, however, set a pattern that was to develop into the Taj Mahal. The tomb chamber was expanded on the basis of the traditional ceremonial entrance to the mosque. The central volume was flanked by two subsidiary volumes, crowned with domed canopies, while the façade beneath the main dome was opened with an enormous flat-pointed arch. The structure was banded and panelled in red and white stone.

During the sixteenth, seventeenth and eighteenth centuries an enormous number of other architectural works in various Indo-Muslim styles was carried out. The most famous of them all is the Taj Mahal. This was planned by Akbar's grandson, Shah Jahan (1628–58) as a tomb for his wife, who died in childbirth. Unable to construct the even more magnificent tomb planned for himself because his son, Aurangzeb, usurped the throne, he lies buried

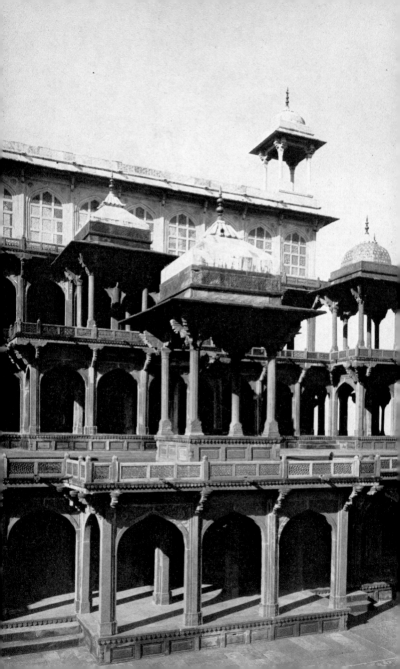

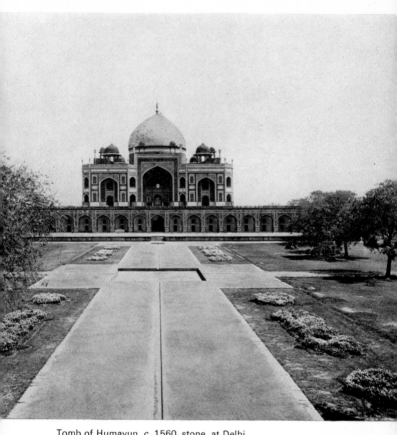

Tomb of Humayun, *c.* 1560, stone, at Delhi

Upper stories of the tomb of Akbar, *c.* 1602, stone, at Sikandra, Agra

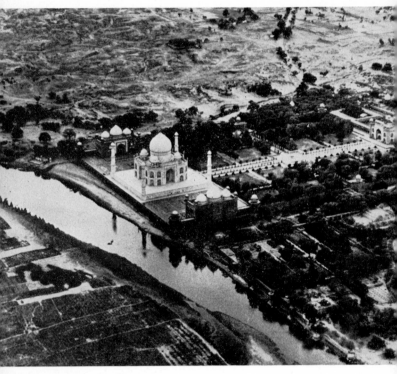

The Taj Mahal, *c.* 1650, at Agra

in the tomb of his wife. The inscriptions suggest that it was built
to the design of an architect from Lahore, assisted by a Turkish
dome-builder, and other craftsmen from Persia and Turkestan.
The material is the white marble of which the emperor was so
fond. The four sides each present a towering arch set in a rec-
tangular surface, like the door to a Persian mosque, flanked by
tall octagonal volumes, whose faces are opened by arched
balconies. A huge bulb dome, raised on a drum, crowns the central
area. The gardens with their water, formally laid out, are bordered
by rows of minarets. The restrained and elegant floral inlay on

Interior of the Moti Masjid, the Pearl Mosque, 1630s, at Agra

the exterior and interior contains precious stones, and nowhere obscures the architectural features. The beautiful fretted stone screens, especially those around the central tomb area, whose patterns are fundamentally geometric and Muslim, are imbued with Indian feeling for vegetative life. Although it is certainly in one sense a work of Indian art, the architectural success of the Taj rests on its fundamental Muslim feeling for intelligible and undisturbed proportion, applied to clean, plastically uncomplicated and brilliantly light-reflecting surfaces.

The Pearl Mosque at Agra, its grey and white added to Akbar's

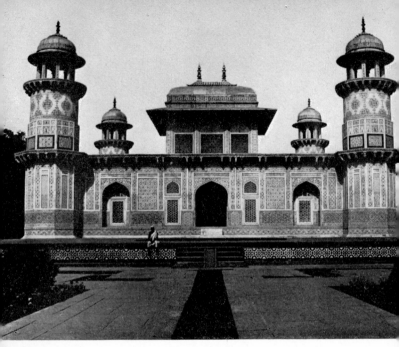

Tomb of Itimad-ad-Daulah, 1622–8, stone, at Agra

Red Fort, shares something of the aesthetic purity of the Taj Mahal. Its beauty rests upon its design and proportion, for ornament nowhere obtrudes, as it does so often in late Mogul architecture. A further notable building is the tomb of Itimad-ad-Daulah, built under Jahangir, on the facing of which dignified stylized cartouches of *pietra dura* inlay are used.

The Mogul dynasty will be remembered above all for the miniature paintings produced under its patronage. Akbar, Jahangir and Shah Jahan maintained one of the most distinguished schools of painting the world has ever seen. It was founded by Akbar mainly as an instrument of his imperial policy, and composed of painters attracted from all over India to serve under the supervision of Persian masters. Its chief task was to illuminate translations from one language into the other of the major texts of Persian and Sanskrit literature. These were distributed to the feudal nobility in order to increase their mutual understanding. A further function was to illustrate in album

paintings the principal events of his reign. This, for Indian art, was an entirely new activity, though the Ottoman Turks had done something similar in the Islamic world.

Such album pictures were designed for close attention, not as a mere background to luxurious life. The crowded and polished surface-composition adopted from the Persian Safavid miniature was given a new seriousness of purpose. The artists of Akbar's atelier worked on each picture as a team, some specializing in the portraiture of the principal characters, others drawing general design, others landscape and yet others applying the brilliant colours. As a consequence of this method of work an extraordinary unity of style and intention came to prevail. Akbar acquired many works of art from foreign sources, including graphic work and woodcarving from Europe. These his painters studied and assimilated. We know, for example, that Flemish engravings of the late sixteenth century were in the atelier, and many copies survive of other European prints—for example by Dürer.

Inlay in *pietra dura* on the tomb of Itimad-ad-Daulah

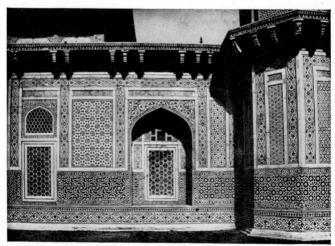

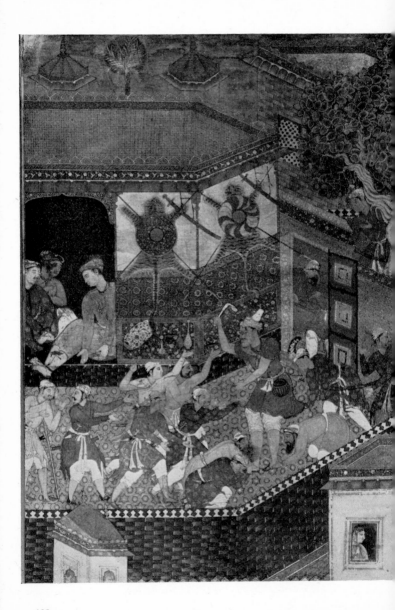

This artistic interchange was not a one-way traffic. Rembrandt, in the 1650s, was drawing copies of miniatures made in India fifteen or twenty years earlier, and other Dutch seventeenth-century painters included objects from Mogul India in their still-life pictures.

Akbar's artists, in the space of some twenty years, worked far away from the merely decorative splendour of the Safavid style. When Mir Sayyid Ali first came to India he began as director of an ambitious programme, carried out by a number of painters—the illustration with large scale 'miniatures' on cloth of a Persian classic called the *Hamzah Nama*. The basic methods of design in which he instructed his colleagues came ultimately from the fifteenth-century School of Herat. Composition was based upon the division of the surface into a series of space-cells framed in architectural or landscape features, within which the figures were placed or grouped, some perhaps cut off at the hips by an edge of the cell, or even by the lower edge of the picture. All Akbar's painters, even those of native descent, to whom a broad and generalizing manner of drawing would have been natural, were thereafter educated in a minutely brushed curvilinear calligraphy derived from Persia. Even so it is often possible to read a difference in the drawing-hands of the Persian and Hindu atelier-painters, who were each influenced by their own different script habits. Expensive pigments were imported to enable the artists to produce those complex sequences of colour across the ground which are responsible for much of the brilliance of Persian painting.

The direction in which Akbar's atelier style moved was this. The space-cells of the composition came to be treated more and more as genuine elements of distance; then as time went on the cells were eliminated, so that the picture became a continuous whole based upon a natural 'floor'. The objects or figures placed on the highest levels of the picture, nearest the horizon, were treated colouristically and in terms of touch and perspective as

Large miniature illustration to the *Hamzah Nama*, c. 1570, gouache on cloth. *Victoria and Albert Museum, London*

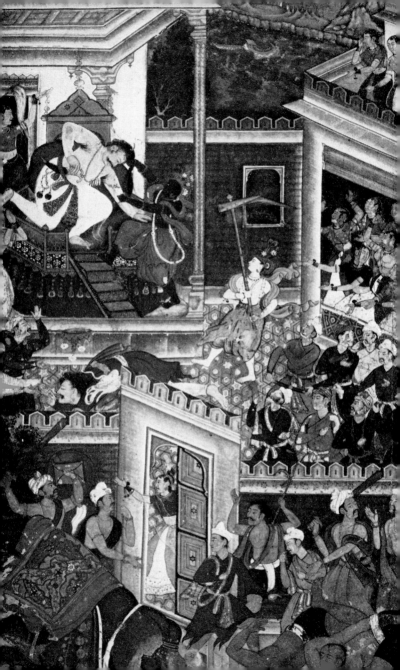

actually distant. These techniques were quite unknown to Persian painting; Akbar's painters learned them from the 'distant views' in European engravings. Safavid tradition had treated even the 'farthest' objects in a design as an integral part of the flat decorative surface. But Akbar's intense interest in the actual, present and real—an interest which was even stronger in his son Jahangir— also drove his artists to modify their drawing styles away from the Persian musical calligraphy towards a minutely descriptive outline, their colour inventions away from musical scales towards visual accuracy. Contours were reinforced both by shading along edges and by bracelet-shading, also derived from European engravings. These helped to emphasize the physical details of portraiture, dress and location. And whereas colour remained strong and bright in the garments, to represent landscape the Mogul artists learned to use subdued tones to distinguish the world of nature from the men who inhabit it.

European influences did not in any sense overwhelm the Mogul style, but only strengthened it. However, even though Jahangir and then Shah Jahan continued to patronize the atelier, the work of the artists gradually lost vigour. Jahangir was interested, in a semi-scientific way, in plant and animal life; so that many miniatures made for him are botanical or biological studies couched in decorative Muslim terms. Under Jahangir, as well, certain themes and types were abstracted from the complex of Akbar art and given a significant separate identity. The most important of these are: individual portrait figures, usually seen standing in profile; and open views of landscape within which some object of interest, like a flowering tree, or an event, such as a hunt, is placed so that the picture almost verges upon pure landscape. Both these genres, however, were dominated by Jahangir's delight in the factual and descriptive, even in morbid and disgusting aspects of reality.

Shah Jahan's successor, Aurangzeb (d. 1707), a bigoted puritan, had no interest in painting at all, and the atelier was

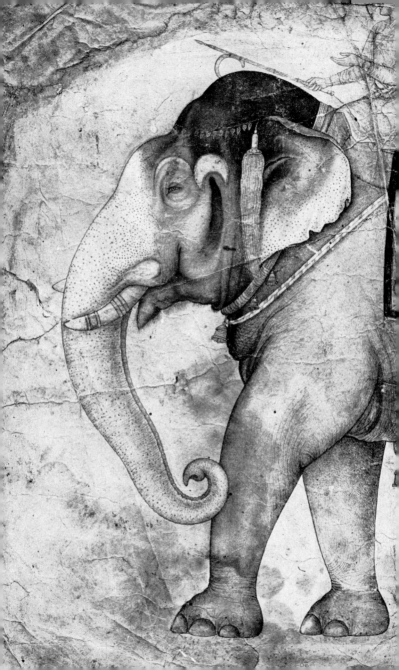

abolished as a luxury. Some of the Muslim aristocracy still maintained their own painters; but most of the artists from the disbanded atelier were forced either to attempt to catch the eye of the casual buyer in the bazaars, thus originating what is known as the Delhi school, or to migrate to regional courts in pursuit of their livelihood. The latter gave great impetus to native Indian Rajput styles, which had already been benefiting to a certain extent from an occasional leaven of artists trained in the Mogul atelier, who had, for one reason or another, left it. At Oudh, especially, an atelier of direct Mogul lineage flourished for decades.

Illuminated page from a Harivamsa manuscript, *c.* 1600 from Akbar's ▶ atelier, showing many different influences. *Victoria and Albert Museum, London*

Perfume box, *c.* 1640, jade, from Shahjahanabad, Agra

Rajput miniature painting

From the seventeenth to the nineteenth centuries artists at the Hindu Rajput and the Punjab hill courts, as well as decorating the walls and doors of the palaces, painted many sets of album pictures in body-colour on paper, following Muslim patterns but representing Hindu subjects. Of a size comparable with the ordinary range of European book-pages, they often deal with romantic love, in particular with the erotic legend of the cowherd Krishna, an incarnation of the transcendent deity Vishnu. The legend describes his passionate love-affairs with the cowherd-girls (*Gopis*) of Brindaban where he was born; the cult of which he was the focus was one of deeply emotional adoration. The deity was approached through love—love interpreted as the highest point of human experience. The art dedicated to him aimed at arousing an inward condition of passionate exaltation by all possible means. The Krishna miniatures illustrate emotionally-charged incidents from the childhood, youth and heroic manhood of the incarnate god which reflect the experiences of all men and women, and which had become staple material for poetry in all the Indian languages. Episodes from other romantic poems and stories, and from the old epic *Ramayana*, were also illustrated. Most popular of all, perhaps, were the series illustrating all the possible moods and passions of girls in love. Following the Mogul example, however, many rulers at the Rajput courts also commissioned their painters to illustrate scenes of court life, ceremonial and pleasure. Actual incidents, such as hawking, hunting or elephant-taming, were depicted very much as they were by Mogul painters. Furthermore, in most states dynastic pride called for sets of portraits to be made of members of the ruling house.

Stylistically the evolution of Rajput miniatures falls into two phases; that before they underwent the influence of Mogul

Miniature painting representing a musical mode, a Ragini, early 16th century, 10 in. high, gouache on paper, probably from Mewar. *Victoria and Albert Museum, London*

painting—which did not happen simultaneously everywhere—and after. The division can be clearly seen in the painting from the State of Mewar. One of the styles descended directly from older Indian tradition had probably existed continuously in the region ever since the Middle Ages. A famous group of illuminated manuscripts of popular poems in such a style are attributed to Mewar, probably made after about 1500 and before 1568, when Akbar sacked the state capital Chitor. Their drawing is stylized into complete and clearly-shaped enclosures, the figures suggesting the cut-out puppets which have always been popular in India. The use of brilliant colour is characteristically Indian, a limited

◀ Miniature painting representing a prince watching a girl at her toilet, 18th century, 12½ in. high, gouache on paper, from Bundi

Miniature painting representing a tiger shoot, 18th century, 14 in. wide, gouache on paper, from Kotah. *Victoria and Albert Museum, London*

group of the same clear, unblended tones—red, blue, yellow, pink and green—being used for every picture in a series. Then between about 1625 and 1640 the revived school of Mewar gradually leavened its traditional style with Mogul methods, to produce a new, magnificent flowering of art.

By the mid-seventeenth century Mogul court customs were accepted virtually everywhere and Mogul elegance was refining the arts of most of the courts of India, architecture no less than painting. In the miniature styles of Rajasthan new standards for attention to visual truth and human scale were being set. Especially fine work was done at the courts of Bundi, Kotah and Jaipur. Somewhat later, towards the end of the seventeenth century, a fresh branch of this art began to flourish in the hill states of the Panjab, appearing first in the state of Basohli, and gradually spreading and developing through the hill courts, especially of Jammu, Guler, Garhwal and Kangra. The Basohli version was at first farouche and emphatic. But by the end of the eighteenth century all the hill styles had become delicate, feminine and sublimely elegant.

The origins of these styles and types of miniature painting have been the subject of much scholarly controversy. The ways in which influences were transmitted make them difficult to disentangle; both artists and collections of pictures migrated from court to court as a consequence of dynastic marriages, economic pressures and political conflict. They all have, though, certain common characteristics.

Most important, the figures are always the focus of attention, the protagonists of the story. Landscape or palace settings are usually a mere frame for the figures without much attempt at optical scale; though late in the eighteenth century in the sophisticated styles of some states like Jaipur, Kotah, Kishangarh and Kangra, an interest in optical scale (derived from European art) did become important. The colours are usually brilliant and flat, laid on within carefully conceptualized, but melodically phrased, closed contours. Most important, the colours are not registered 'naturalistically'. Not only clothing but landscape and palaces may be given brilliant emotive tints—reds, oranges, lilacs. Different scenes are each given a calculated emotional force by

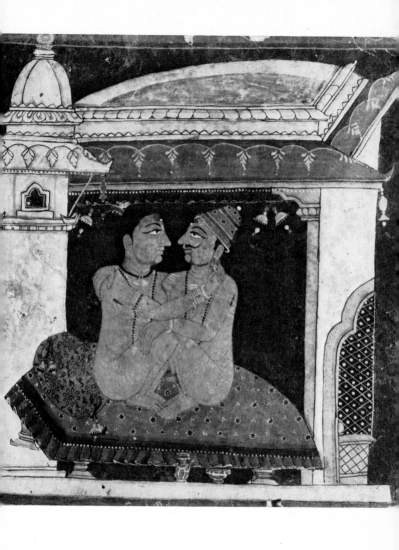

Miniature painting of a pair of lovers, 17th century, 6 in. high, gouache on paper, from Nepal. *Victoria and Albert Museum, London*

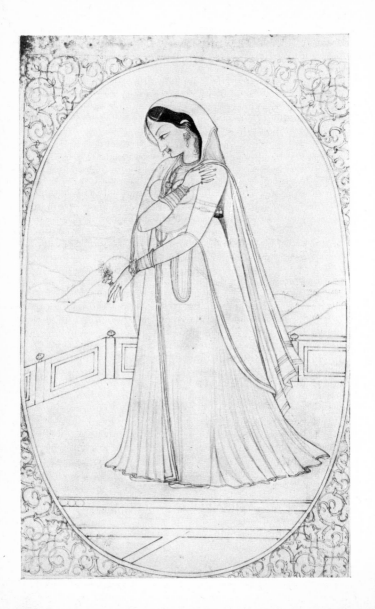

means of the particular selection of colours used in the picture. In fact, colour is the main vehicle of feeling in these works, rather than drawing and movement. For in all native Hindu painting the figures and their gestures continue to follow types based on simplified areas of volume which do not allow much play to the melodic line.

Aesthetic theory related this kind of painting very closely to music. Following a pattern invented by Hindu painters working in the Muslim state of Ahmadnagar in the Deccan during the second half of the sixteenth century, many of these pictures were made in sets, to illustrate poems which themselves expressed the varied emotional flavours of the different 'modes' of Indian music. Such sets are called Ragamalas (garlands of modes) and illustrate the crucial phases of love. Pictures with much strong

◀ Rajput drawing, representing a girl in love, *c.* 1780, 10 in. high, brush and pigment on paper, Kangra style

Miniature painting representing an episode in the love life of Krishna and Radha, *c.* 1690, gouache on paper, 13 in. wide, from Basohli. *Victoria and Albert Museum, London*

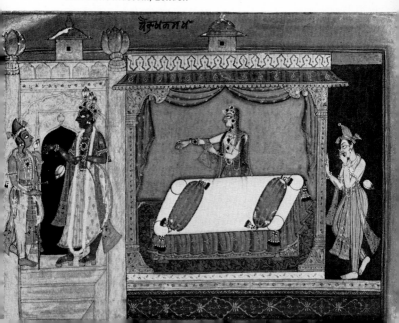

red, orange and bluish-green obviously have a very different 'flavour' from those dominated by lilac, dark green and pale yellow, just as do musical modes whose basic note-patterns differ. For example, in the Panjab hill state of Basohli, during the late seventeenth century, the palette used with the farouche drawing was very wide, with acid greens and lemons, chocolate and turquoise blues added to the normal Indian range of brilliant primary colours. In the late-eighteenth-century styles of the hill states of Guler, Kangra and Garhwal, against the dark greens and greys of the landscape, pale bodies and clothing in light secondary colours, especially lilac, produce an effect of delicate coolness.

Perhaps the epitome of this style of painting appears in the work produced at the small court of Kishangarh around 1730–50 under the inspiration of an artist called Nihal Chand. He worked for the Rajah, Savant Singh, who was himself a distinguished poet, and whose chief mistress, Bani Thani, was a fine poetess. Nihal Chand's large miniatures set in vivid spring-time landscape Krishna's love affairs with the girls of Brindaban. Between dense banks of trees populated by bright-coloured birds the lovers glide in a red boat on the grey Yamuna. Above, the sky is streaked with sunset red and cockled with gilded clouds. There can be little doubt that the reality of the royal love-affair was a special stimulus to the artist to 'realize' in his work the divine prototype.

The image of human identity that Rajput miniatures present is not the same as that conveyed in previous Hindu art, with its dedication to the cosmic and colossal. Krishna is god; but he was incarnate on the Indian soil at a definite point in time. His birthplace was Brindaban on the river Yamuna, today a holy city filled with temples. The participants in the painted dramas were always imagined on the human scale, although Hindu artistic conceptions—like the social—were still governed by types. But they were usually shown acting on the human plane. Their magical performances were worldly miracles, not cosmic commonplaces. The sublimely handsome princes and divinely beautiful ladies were romantic ideals of humanity calculated to appeal to the

Miniature painting, an imaginary portrait of Radha, perhaps an idealized picture of Bani Thani, perhaps by Nihal Chand, 1735–57, gouache on paper, from Kishangarh

girl in ♡

Base of a temple, *c.* 1600, stone, in Kulu, Panjab hills

courtiers, especially the women, for whose amusement the pictures were chiefly painted. But when, in some of the miniatures, the old high gods of Hinduism were represented, either as icons or paying homage to Krishna, they abandoned their former overwhelming splendour, and were shown in human guise. Something similar happened even in the ornament of certain Panjab hill temples.

This must be partly due to the influence of Islamic painting, which was always absorbed in recognizable individuals and anecdotal reality. Certainly the portraiture and historical document which appear in later seventeenth-century secular Rajput painting could never have been conceived without the example of Akbar's and Jahangir's artists. There may have been traces of the same sort of interest in Indian secular painting we have lost; for the Jain miniatures illustrating lives of the saints and Mewar illuminated manuscripts before 1625 tell stories at the human level with very stereotyped figures. In later Rajput miniatures, however, there is a definite tension between the native Indian fondness for type rather than individual and the Muslim sense of

(Pps 152–153) Miniature painting representing a Nautch (dance) party, early 19th century, 12½ in. wide, gouache on paper, from Tanjore. *Victoria and Albert Museum, London*

human scale and interest in the world of nature and human personality. In some Rajput schools (e.g. horse-loving eighteenth-century Kotah) the Mogul fascination with registering pictorially a real landscape was so much developed that the actuality of the setting of a scene from court life can far outstrip the actuality of the figures it contains. However, in all the Rajput styles, actuality was always subordinate to colouristic and linear fantasy. Their enthusiastic and courtly hymning of their topic excludes all that is unpleasant and hinders delight, enthralled with conventional charm rather than visual fact.

Miniature painting illustrating the story of Krishna's old Brahmin teacher, late 18th century, gouache on paper, from Guler. *Victoria and Albert Museum, London*

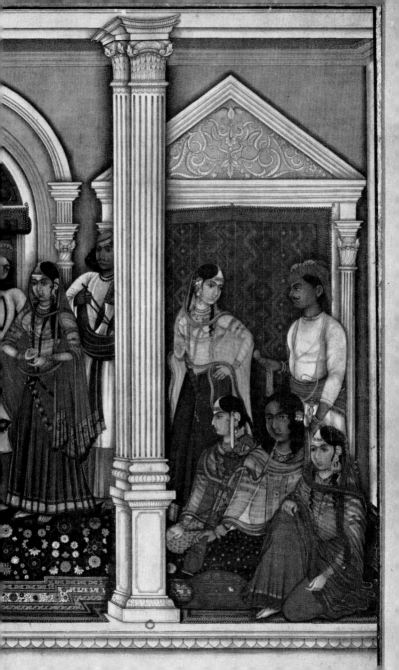

Minor arts

Many minor arts were practised in all parts of India during the sixteenth to twentieth centuries. In many of them varying degrees of Muslim influence can be found. Outstanding was the art of textile dyeing, weaving and painting. Fine cotton fabrics dyed by many complex techniques had been an Indian speciality probably for millennia, and numerous types invented in India were bought and imitated in other parts of the world, including western Europe. Examples are resist-dyeing, pick-and-tie dot and certain very sophisticated tie-and-dye patterns. Some of India's woven patterns, like the Benares silk saris, are inimitable; the fine Islamicized goats' wool shawls of Kashmir prompted imitative industries in Britain and France. The most artistically significant textiles were, perhaps, the cloths painted or resist-dyed with stylized scenes from Hindu mythology and decorative designs; those painted in the south in native Hindu style, especially, became an important article of international trade during the seventeenth century; so, too, did the superb carpets made in north-western cities under direct Persian influence. In the Mogul centuries jade was worked for the court, and many fine pieces in floral shapes were cut, some inlaid with gold and gems. This craft still survives.

Other minor arts include metalwork of all kinds; swords, temple and domestic lamps, bowls, pots and dishes as well as most beautiful jewelry were made in stereotyped designs, often incised, enamelled or inlaid. Wood-carving and turned woodwork coated with brilliant lac-colours, as well as painted papier-mâché work, such as the fine Kashmiri book bindings, formed part of an enormous decorative industry.

Sword, with Hindu hilt and elaborated type of Muslim blade, with European-style channels, 18th century, steel from south India

Modern arts

Art in modern India has had a chequered history. In Portuguese Goa an Indian style of Catholic art emerged. Under British rule during the nineteenth century some native styles continued at a humble level. In certain places native artists assimilated British watercolour techniques, notably under the Sikhs at Lahore, and in the bazaars of the Ganges valley. But a consciousness of 'art' in the modern Western sense first developed with the sentimental revivalism of the Bengal school founded and patronized by the Tagore family. Certain artists, following Jamini Roy in Bengal, attempted with some success to rehabilitate the remnants of peasant styles. More recently artists have made a sustained attempt to absorb movements in Western cosmopolitan art—Cubism, *art brut*, action painting, hard-edge conceptualism and Pop—usually in a somewhat sentimental vein. But in the last decades a number of Indian painters have made a great impact on the world's art, largely because of the way in which they have rediscovered the roots of Indian imagery through an exploration of techniques and forms in the Western manner. Prominent names are F. N. Souza, Avinash Chandra, M. F. Husain and Swaminathan. But in fact there has long been an art in close touch with its own roots, which is only now being discovered, almost on the verge of extinction. This is the art of the people, who make deities and offerings of clay and dough, or bronze, very much as they have done for millennia. Most important of all, perhaps, is the fact that this art is not only rural. The urban masses have their own popular arts which are only just now succumbing to Western commercial influences. It is from this direct religious imagery, often made with a most vivid tactile sense of order, to which no other country knows a parallel, that the art of the twentieth century may be refreshed.

Selected bibliography

The Aesthetic Experience according to Abhinavagupta by R. Gnoli, Istituto per il Medio ed Extremo Oriento, Rome 1956

The Art of India by S. Kramrisch, Phaidon, London 1954

The Art of Indian Asia by H. Zimmer, Bollingen Foundation, New York 1955

Development of Hindu Iconography by J. N. Banerjea, Calcutta University, second edition 1956

Elements of Hindu Iconography by T. A. Gopintha Rao, Law Printing House, Madras 1914–16

The Erotic Art of the East by P. Rawson, Putnam, New York 1968

History of Indian and Indonesian Art by A. K. Coomaraswamy, Edwin Goldston, London 1927

Iconography of Buddhist and Brahmanical Sculptures in the Dacca Museum by N. K. Bhattasali, Dacca 1929

India: Five Thousand Years of Indian Art by H. Goetz, Holle and Co., Baden Baden; Methuen, London 1959

India in Photographs by R. Lannoy, Thames and Hudson, London 1955

Indian Painting by P. Rawson, Universe Books, New York 1961

Indian Sculpture by P. Rawson, Studio Vista, London: Dutton, New York 1966

Indian Temples and Sculpture by L. Frederic, Thames and Hudson, London 1960

Journal of the Indian Society for Oriental Art Calcutta 1933

Lalit Kala Journal, New Delhi 1955

The Loves of Krishna by W. G. Archer, Allen and Unwin, London 1957

Marg Journal, Bombay 1947

Myths and Symbols in Indian Art and Civilization by H. Zimmer, Bollingen Series, Pantheon Books, New York 1946

Sanskrit Poetics as a Study of Aesthetic by S. K. De, University of California 1963

Index

Figures in italics refer to illustration pages

STUDIO VISTA | DUTTON PICTUREBACKS
edited by David Herbert